Lives in Architecture

Terry Farrell

Lives in Architecture

Terry Farrell

RIBA Publishing

© RIBA Publishing, 2020

Published by RIBA Publishing, 66 Portland Place, London, W1B 1AD

ISBN 9781 85946 933 0

The right of Terry Farrell to be identified as the Author of this Work has been asserted in accordance with the Copyright, Designs and Patents Act 1988 sections 77 and 78.

All rights reserved. No part of this publication may be reproduced, stored in a retrieval system, or transmitted, in any form or by any means, electronic, mechanical, photocopying, recording or otherwise, without prior permission of the copyright owner.

British Library Cataloguing-in-Publication Data
A catalogue record for this book is available from the British Library.

Commissioning Editor: Ginny Mills
Assistant Editor: Clare Holloway
Production: Richard Blackburn
Designed by CHK Design
Typeset by Fakenham Prepress Solutions, Norfolk
Printed and bound by Pureprint Group, East Sussex
Cover image © Morley von Sternberg

While every effort has been made to check the accuracy and quality of the information given in this publication, neither the Author nor the Publisher accept any responsibility for the subsequent use of this information, for any errors or omissions that it may contain, or for any misunderstandings arising from it.

www.ribapublishing.com

Contents

	Acknowledgements	vi
	Introduction	vii
1	A Family Background	1
2	The 1940s	7
3	The 1950s	15
4	The 1960s	23
5	The 1970s	39
6	The 1980s	127
7	The 1990s	145
8	The 2000s	157
9	The 2010s Onwards	167
	Endnotes	176
	Image Credits	178

Acknowledgements

Firstly, I would like to thank Helen Castle, RIBA Publishing's director, for approaching me and putting to me the very idea of writing my memoir. I know Helen well from previous books, and my history with her was key; but so helpful also were the whole RIBA team including in particular Ginny Mills, the commissioning editor, and Clare Holloway, the assistant editor.

Secondly, I would like to thank Emma Davies, who typed, re-typed and yet again re-typed all these chapters from my tape recordings and notes, very rough adaptations which are virtually unintelligible to anyone but her. Emma was much more than that, though, as she commented, edited and helped me get the tone and content right as well as collect together the book's images. Then there are those who proofread and added editorial comments, which must include my daughter Bee Farrell, and Abi Grater, who has the final edit on all my various writings.

Finally I would like to thank the many people who have helped make my life in architecture and planning so worthwhile. My teachers, beginning of course with Maurice McPartlan, then the many at universities in Newcastle and Pennsylvania. During a long career I have worked with so many great partners, workmates, assistants, clients and consultants too numerous to mention. If I have to single anyone out it would be Maggie Jones, my personal secretary for 41 years, and Brian Chantler, our accountancy and legal adviser, who has been my guide and has remained my closest workmate for well over 30 years.

This memoir is dedicated to all these people and my grandfather, Jim Maguire, who showed me through his collected papers the value of keeping track of a life for the record and for future generations.

Terry Farrell
London, 2020

Introduction

My ancestors were from the farmlands of County Galway, Ireland. Like those of many other migrants who adapt to their new surroundings, my family's story is one of continuous change and integration. It is a survival and aspirational instinct that I have inherited and then developed that has enabled me to pursue my chosen professions of architecture and planning.

It was my maternal grandfather, Jim Maguire, who encouraged me to think ambitiously and welcomed my academic progress. He gave me a briefcase embossed with my initials as my getting-into-university present, whereas my parents with a passive acceptance of 'their lot' were much less enthusiastic, and transferred their anxiety about my aspiring to study for a professional career on to me. Nonetheless, with Jim spurring me on I began five decades of earning my professional status to challenge the dominance of class elitism in British architecture.

Social mobility is difficult but not impossible, was Jim's message to me. I spent some of my childhood growing up on a housing estate on the northeastern edge of England, where Newcastle spills over into Northumberland, and where aspirations were limited by a lack of opportunities and by guarded expectations. Society and the architectural profession in particular are at the centre of all this. The structure of society is far too rigid and adheres too much to the past, and architecture is historically class-elitist, which results in a deficit to our skills and enterprise; it makes us poorer culturally and economically. One thing I have learned is that we should make it easier for the aspiring child, because all too often society is not fair and not remotely equal. So the message I hope to demonstrate through my writing and archives is 'you can do it too', as well as an overarching idea that we all collectively make our society.

Sport and athletics have dominated successful emergence from working-class roots in the Northeast. Yet statistically over 40% of the medals won by British sportspeople at the last two Olympic Games went to privately educated people, a group that accounts for just 7% of the British population.[1] I had always thought that athletics – my first love – was purely talent-driven, but this is clearly not the case. There are much larger forces at play. Sports other than athletics are even more unfairly represented: in rugby union's 2007 World Cup squad, the proportion of privately educated players hit 60%; and at Lord's in 2011, an England cricket team comprised eight privately educated players and only three state-educated ones.[2] The educationally privileged

have so much more available to them in terms of knowledge, coaching, time and medical support. All this is in their arsenal from an early age – which, combined with confidence, good leadership examples and the investment of time and energy, creates a very uneven and disadvantaged playing field for the other 93% of our population. The performing arts are no different: even though actors and particularly pop musicians like Sting and Bryan Ferry emerged from the Northeast to international fame, some 20% of BRIT Award winners and 60% of British winners of Oscars have been from private schools.[3]

The same is true for architecture as it is in these other fields. Architecture in the 1960s and later had very limited availability to someone like me, from my background – from the edge of the edge. I realised early on in my professional career that to challenge this and be socially mobile was more difficult than I could ever have anticipated. With every rung of the social ladder that must be climbed in this country, values have to be continuously re-examined.

My memoirs are arranged chronologically and also reflect on the known roots of my Irish family. From my childhood successes in art, to my octogenarian years reflecting on the challenges, adventures and successes of my career, I express my personal and professional struggles, the constant reinvention and professional achievements.

Chapter 1 illustrates my grandfather's tough immigrant background and its motivational impact on me. Next, in Chapter 2 (1940s), my early childhood character-building adventures are revealed as core to helping me develop the traits of self-reliance and an ability to communicate that have proved so crucial throughout my life. Chapter 3 (1950s) details my struggles with academic criticism and then my life-changing discovery of drawing and architecture. Chapters 4 (1960s) and 5 (1970s) portray my early professional career as one of academic achievement, global study travels, and feeling empowered and stimulated. It was a time when I was essentially gaining the cultural capital needed to move ahead in architectural partnership with Nick Grimshaw. My independent architectural years of developing my Postmodernist thinking, and venturing to work and set up practices in Hong Kong and Scotland, are described in Chapter 6 (1980s) and Chapter 7 (1990s), two decades of great energy and reputation-building. The next chapter (2000s) changes pace, with my ability to feel the results of earning my status with my knighthood, writing a series of architectural books and my confidence to tackle urban masterplanning projects. The final chapter, 9 (2010s), relates my sense of accomplishment with the governmental request to produce the Farrell Review of Architecture and the Built Environment, as well as inclusion in a three-part BBC television series, *The Brits Who Built the Modern World*.[4] Yet this chapter has been the hardest to write, as it seeks to relate the succession plans for the practice that will enable it to build on previous successes yet be able to reinvent itself in the face of global change and national economic uncertainty. It is in essence the chapter in which I assess my social mobility, the ways in which I earned or achieved my status against the odds of not being born with the automatically acquired status of the privileged social class, and how much I have passed on. And it is the chapter where I make recommendations for social mobility in our architectural careers, which will have a double benefit. It will hopefully make it much easier to bring

so many able young people to contribute more to the architectural profession, and it will help broaden the very culture of architecture so that its efforts are not solely concentrated on haute couture, but on dealing better with the world that we all live in, such as our streets, mass housing and hospitals.

This frank memoir is therefore an opportunity to acknowledge how I circumnavigated the limitations of my social class, in my search for social mobility, by acquiring skills, a respected reputation and cultural capital.

A Family Background

I will begin with my grandfather Jim Maguire (my mother's father). When he was my age now (early eighties), he recounted his own life and what he knew of his parents' to me over the course of many visits I made to the house he retired to, which was around the corner from my parents' home in Lytham, Lancashire. I was the first in my family to go to university and he took a shine to me, seeing in me aspiration and application. He singled me out and in an act of symbolically passing the baton he gave me his many letters, postcards and mementoes that he had kept all his life. This was what would spark my desire to archive my own life, tell stories about it and look back to make some sense of it all.

The story Jim told began around 1880, as six brothers left their deeply rooted and inevitably unrecorded agricultural existence in Glenamaddy in County Galway, rural Ireland, for America. His father (my great-grandfather) Patrick Maguire was one of those brothers, forced to flee their vernacular clay- and peat-built homes surrounded by blighted potato fields to seek refuge and a better chance of survival elsewhere. They are typical examples of the desperate individual, family and group action that spurs mass migration. Frightened but determined, they fled a famine that could have been prevented had it not been for the English class, race and religious prejudices against the Irish.

On arrival in Liverpool for onward voyage to the New World, Patrick was singled out, as his wife was eight months pregnant. They refused to take her on the next ship so, having been denied emigration, he stayed in England and looked for work in Liverpool and Manchester. He would never know the fate of his brothers who continued their

journey. My grandfather Jim was born in Gorton, Manchester a few weeks later, in 1880 or 1881. His mother died giving birth to him, and the cause of death on the doctor's certificate was given as malnutrition combined with childbirth. Desolate at the loss of his wife and brothers, Patrick became a drunkard and virtually abandoned Jim, who was subsequently brought up by neighbours.

Gorton, like the other Manchester neighbourhoods where the Irish community was concentrated at the time, was a far from salubrious place. As Tristram Hunt reports in *Building Jerusalem: The Rise and Fall of the Victorian City* (2005), a number of 19th-century writers commented on the particular levels of poverty and disease that they suffered, sometimes in disparaging and even brutal terms:

> Living together in typically the most unsanitary areas of the city, the Irish gained a reputation not only for having disease but actively spreading infection … Their filthy bedding, their lack of furniture, their unclean habits and their crowding together in tenements meant the Irish were frequently vehicles for communicating infectious diseases. But it was their moral condition, not least their Roman Catholicism, which so appalled the Victorian Englishman.[5]

The Catholic Church was to dominate so much more than my religious background – it affected all our educational, economic and social life (including domestic life) for over 100 years. It saved my grandfather's generation, began to control and eventually imprison my parents' generation, and I was part of a transitional generation that freed themselves from the hold that it had on us all.

By the time Patrick Maguire arrived there, Gorton benefited from the presence of an order of Franciscan monks. They had come from Belgium in 1861 and saw themselves as having a calling to serve Britain's poverty-stricken Irish community. The monks, like the Irish, were Roman Catholics, and arrived not long after the ban on Catholicism had been lifted in England as a result of the early-19th-century Catholic Emancipation Acts. Their friary, dedicated to St Francis of Assisi, was built between 1863 and 1872 to designs by Edward Pugin, following in the Gothic Revival footsteps of his more famous father, Augustus Welby Northmore Pugin, who is best known for co-designing London's Houses of Parliament. (Augustus's wife had died giving birth to Edward, echoing Jim's own life story.) The building had an astonishing and dominating presence, looking axially down the dense surrounding streets and seeming to grow out of the community with a physical, architectural, town-planning connection to them and the houses they contained, as can be seen in early photographs. It is considered the architect's finest masterpiece, and was for some 100 years the very hub of Gorton's religious, social and cultural life: the Franciscans ran three schools, a theatre group, a brass band, a choir, a youth club, successful football teams and numerous other activities for the community. (Figure 1.1)

As a child, Jim was sent to one of the Franciscan schools – evidenced by a letter that his Company Sergeant Major from the Mesopotamian War wrote to him, which mentions that they both went to the 'Monastery'. (Figures 1.2 and 1.3) There cannot be any doubt that the friary would have been a key differentiator, and that Jim's quality of

life was considerably improved by the church and the friars. And so, after his parents' extraordinarily depressing and suppressed beginnings in a hovel in rural Ireland, through famine, immigration and his mother's death giving birth to him, began a rise in Jim's fortunes, steadily and inexorably.

* * *

Jim didn't want to merely survive; he wanted to prevail and, in his own modest way, succeed. And indeed he did so. I was seriously motivated by talking with him in the 1960s. His story, as he told me, is one of joining in with the imperialist/colonial world power at that time – he lived through the Western world's rise in affluence and life expectancy, and his life was quietly remarkable. The traits which I've inherited from him, I believe, are his grit and determination to survive along with a love/hate relationship with all the circumstances that he found himself in, and a sense that the lessons of continuous change, integration and flexibility are essential to endure and prevail.

Jim survived through a combination of joining two institutions: the Catholic Church and the monastery in Gorton on the one hand, and on the other the army (he always said he was underage when he joined). He went on to fight in the Boer War (Figure 1.4), where he developed his sense of adventure and risk-taking. The sense that those conquered by imperialists seek salvation through them – it was ever thus and undoubtedly it was for Jim – asserts a tension between the rebel and the conformist that exists in me to this day. His army adventures in South Africa were ended by his coming back to Manchester and Gorton to start a family in the early 1900s, when he was in his twenties.

He became a Manchester Council tram driver between the Boer War and being called up for the First World War, drawn to the security provided by a dependency on the state. Trams had been almost non-existent in Manchester in 1900, yet were everywhere by 1910! In favour of home rule and independence for Ireland, his home country, he also led strikes – for there were many at this time, not only among the tram drivers, but because widespread social unrest was the norm. He joined in with this as a form of rebellion, yet also knew when to conform to survive.

With a dislike for Churchill that started with the Boer War and lasted his entire life, Jim was aware of the Siege of Sidney Street (1911), which flushed out the so-called anarchists and those involved in the social unrest, from what my grandfather would have considered the 'gaffers' end' – the officers' end of the spectrum.

Conflicts in his values were demonstrated by First World War conscription. During time spent on the Western Front he volunteered to rescue an officer from no-man's-land, and was later awarded the Distinguished Conduct Medal (DCM) before being sent to Mesopotamia (now Iraq), which was being held by the Turkish and Germans. This region was always a fault line, even then, and Jim was sent to relieve the garrison at Kut, led by the arrogant General Townshend. The siege ended in ignominy and surrender. My grandfather was shot through the head and bayoneted several times – and was reported, in a letter to my grandmother which he later gave to me, as among those killed in action (my mother and two siblings had been born at

this point). A requiem mass was held at Gorton Monastery for him, followed a short time later by a letter (which I have, written using his left hand and only one eye) from him saying he had survived and was in hospital in Baghdad (Figures 1.5–1.8). Jim saw terrible things being done to the ordinary soldiers by the Turks, and received treatment himself for severe wounds with just iodine, but was saved again as a direct result of his Catholicism, which granted him nursing care from hospital nuns in the Catholic Convent in Baghdad. While over half the men did not survive in captivity, the officers were treated very differently and General Townshend, who had caused all of the mayhem and had allowed the harshest imprisonment and cruel deaths of his men, spent the rest of the war in a kind of holiday camp for senior officers in Constantinople (now Istanbul), where his wife and dog were allowed to join him. It's hard to feel anything but resentment at the inequality of the whole affair, and I still carry the message of Jim's stories with me, even today. Afterwards Jim was demobbed via hospitals and spent some time recovering from being shot in the head, losing an eye and being bayoneted. When he returned to England he was for some time a shadow of the man who had begun the war in 1914.

However, it has to be said that during Jim's lifetime, things improved. Life expectancy in the UK and Ireland doubled; his grandson (me) went to university; Jim owned his own house in the retirement town of Lytham St Annes; and he shared in the wealth and progress that was happening all over the Western world. He lived to be over 90 years old, and during his lifetime also saw the invention and development of the motor car, telephone, radio, aeroplane, television, computers and space travel. Before he died in 1973, he had travelled to America by plane and watched men landing on the Moon on TV in his own home. He outlived most of the mourners at his first Requiem Mass, survived another 50 years and had his second Requiem Mass in the same Gorton church.

I sometimes wonder if a similar story could have been told by my other grandfather, James Farrell, but because he died when I was still very young, in the 1940s, and didn't keep any papers to pass on, I didn't really know him or have the opportunity to share his stories. (Figure 1.9)

What I took from Jim's experiences was the sense of a dawning awareness of the social mobility ladder, with us as a family starting on its lower rungs and beginning to progress up through determination and endurance. I've taken a diligent approach to keeping records of my own life, mirroring Jim's practice as it meant so much to me at a crucial time. I've kept all my school drawings and all my projects and notes, so it's a substantial archive of my life that I am setting up at my former university, Newcastle. There will be an archive and Farrell Centre, the equivalent of Jim's memoirs – the whole endeavour begun, I like to think, by him.

* * *

I should touch on my parents and how they experienced being descended from Irish immigrants, refugees from famine. Unlike Molly, my mother, who was brought up with the hardships of Jim's demobbing and incapacity to work after the war, I believe my father Tom Farrell had a much more peaceful and consistent childhood.

Tom was a quiet, sensitive man. In his childhood his family performed traditions like Mummery, a kind of play-acting from Ireland, and he could also play the violin. He left school at 14, as was the norm, but in his own quiet way he too had a story of progress and betterment. He began working life as a telegraph boy, as he loved riding bikes (he road-raced on his bike at the Belle Vue Stadium), then became a postman and afterwards a sorting office clerk. By the time he married my mother, nearly ten years after he left school, he had passed the Civil Service exams and become a clerical officer. He would have left school at the outbreak of the Great Depression and General Strike, so from early on believed vehemently in state employment and accepted the life of a civil servant with its security and pension.

I felt an attachment to my dad and that was reciprocated, but in an unremarkable and undemonstrative way. I eventually came to feel that he was too obedient and subservient to the priests and the Catholic Church, and this came out with his easy acceptance of my deputy headteacher, Father Cassidy, recommending that I was not sixth-form material and that I would struggle at university. I felt my father had let me down and hadn't defended me.

Artistically and in terms of aspirations my dad was a role model for me in an unassuming way, and I always associate him with Ravel, the composer of his favourite music, and with Thomas Gray's 'Elegy Written in a Country Churchyard' (written 1751), his favourite poem. I thought it spoke volumes about him and I still remember the lines that he encouraged me to learn:

… Full many a flower is born to blush unseen,
And waste its sweetness on the desert air.

Some village-Hampden, that with dauntless breast
The little tyrant of his fields withstood;
Some mute inglorious Milton here may rest,
Some Cromwell, guiltless of his country's blood.

Tom epitomised that sentiment for me, as it was partly his choice of the Civil Service and his obedience to the Catholic Church that had left him, as it were, in a desert in a country churchyard, 'flowering unseen'.

My mother, Molly, was a much more purposeful and outspoken character, from a background where her father had been absent, had been reported dead, but had returned from the war a broken man in terms of health and spirit. She was bright and quite well-educated, and stayed on at school until the sixth form. However, such was the prejudice against women at the time that, while training to be a teacher, she realised female teachers were doomed to become life-long spinsters, given that if they married, they had to resign. My mum described herself to me as a person who had a nervous breakdown at 18 when she realised her career ambitions equalled not having a normal and fulfilling family life. And so she opted to abandon her career and become a laundry clerk. As a result she was forever a fearful person in relation to ambition. She did not support my early athletic ambitions, because she feared I 'would have a heart attack', then she opposed my university ambitions and even entry

into sixth form, because she believed if I worked and studied too hard I 'would have a nervous breakdown'. She did get all of us to change schools to give us a better chance at the eleven-plus, which I benefited from because I went to grammar school. But her ambitions for us as children seemed to stall at that point; she was fearful of us trying too hard, because of her teenage experience. My mother was full of conflict between compliance, going with the flow and submitting to the forces that were all around her – immigration, war, the Great Depression – and, on the other hand, a competitive streak which surfaced now and then throughout her life … whether it was with other mothers or over her sons passing the eleven-plus. But in the end she was basically a reluctantly compliant person.

* * *

The dislocation and brutality of modern urban existence brought about by enforced immigration, particularly of my great-grandparents' and grandparents' generations, was felt by my parents – whose job it was to make sense of it all, and to have lives that, through slow acceptance and gradual integration, aspired to be 'normal' for their children: my three brothers and me.

Money and stability were slowly percolating down the social order by the time this background era ends, but it was still very much a story of reluctant acceptance of the old ways, to avoid social unrest and get the armies willingly massed and fighting wars, and during peacetime to promote mass employment. To facilitate this situation the upper classes reluctantly gave titbits away slowly, steadily and surely to the lower social orders, but it was an enforced 'bottom-up' process – labourers had to fight for it, and refugees particularly.

In summary, I am descended from refugees/immigrants fleeing from famine and colonial rule – where there was an essential unfairness of life that was reluctantly accepted in order to survive. They saw the leaders and generals had made such an arrogant hash of the whole thing, but they, the ordinary working people, almost entirely bore the brunt of these failures. It was a process of gradualism – the social hierarchies were very slowly breaking down, but institutional hierarchies like the Catholic Church were dominant in my parents' and grandparents' lives, together with the class system – which remains a huge force in British society.

The 1940s

My love of things 'creative' was born in my early years in Manchester, triggered and nurtured by my parents', and especially my father's, involvement. I have always seen the act of creativity as being rooted in transformation – all seemingly fixed states are transitional conditions that we nudge, push, massage and lead into new states. During my childhood I would see railway sleepers, which had been made out of trees, reassembled to become a bombproof underground shelter, and then reassembled again to create a make-believe jeep. And so it was with the larger environment – for example, open fields were transformed into streets, among them the very building that was our family's first home. Likewise, one day I would see larger and larger transformations, and entire parts of the city would evolve, linking past, present and future.

I inherited my parents' and grandparents' struggle, but wasn't overly conscious of it – one isn't at a young age. I was vaguely aware of it, though; it was in the air. My parents were definitely upwardly mobile, starting off as clearly working class, but by the end of their lives they had become lower middle class. They spent most of their lives coming to terms with immigration and gradual integration. But there were conflicts all around, with compliance and survival uppermost in my parents' minds, I am sure. According to popular mythology, the Second World War was won by Churchill and the Establishment, but both were then rejected politically in the general election that immediately followed in peacetime. All this had a major effect on my family and, I should add, the turn of events had their full support.

My birthplace – Sale, part of outer Manchester – was, and still is, no more than a typically English suburb-cum-small-town, yet I dwelled on and absorbed every part of it. I was born just before the Second World War and remember bombs dropping and a plane that crashed in the front garden in the next street, demolishing the front wall and its little wrought-iron gate. In our own road, untypically for the English, a giant street party was held for all the local children on VE Day in 1945. At one end of the street was a little bow-windowed newsagent's shop where, for us children, the only reading matter available was American Marvel comics, until the great day when *Dandy* and *Beano* were published again, with Dudley D. Watkins's characterful renderings of Desperate Dan and Lord Snooty. It was in the same quiet, untrafficked street that I learned to ride a bike at the age of six, with my dad running behind holding the saddle. The need for a bike and the emptiness of the street were both features of the unplanned, formless character of the Manchester suburb.

I often sat at a table in the front garden of our house, at 17 Langdale Road, making buildings from pre-printed paper cut-out books that my mother bought me. I eventually assembled a small town of houses, castles and forts, all connected and glued with marked tabs. This method of making three-dimensional objects from drawings was a childhood version of creating built environments from architect's drawings. Assemblages from a kit of parts passionately absorbed me, as did fretwork – cutting intricate shapes with a fine-tensioned saw blade. With this tool I made 'useful' things – letter racks, waste bins, toast racks, fire screens – from cheap materials, with decorative results. The sheet materials were merely one step on from paper cut-outs, and the objects I made had similar two-dimensional components layered, lapped and joined together. It was all done very simply and at minimal cost – we were living in a postwar era of shortages and rationing, whose products were later dubbed 'utility style'.

The particular magic in model-making, as in all miniatures, is that the scale reduction allows the model-maker to see how all the parts fit together to make the whole. Small worlds evoke a thrilling illusory power as we touch, feel and manually revolve those representational objects to comprehend from a giant's simplifying perspective the seemingly myriad complexities that went into making them. There is something akin to role-swapping, too, in that the adult world is brought within a child's range, and the child is empowered to handle, with their imagination engaged, the larger world around them. I have kept many of the architectural models from my career and – as in Sir John Soane's house in London's Lincoln's Inn Fields – the Lilliputian representations of buildings, which will all be included in my archive at Newcastle.

My father introduced me to larger constructional ambitions. With my Uncle Jim, my mother's elder brother, I 'helped' to dig an enormous hole in the back garden, which was then lined with railway sleepers and turfed over to make an air-raid shelter. I remember sitting there many a time late at night during the war, under the back garden with my parents and brothers, listening to sirens and bombs and thinking how cosy and exciting it was. Immediately after the war I helped Dad dismantle the shelter and reassemble the sleepers to make an open-topped 'jeep'. We went together to a nearby car-breakers' yard to buy a steering wheel; it was fixed on to a frame, which

instantly became a full-size four-seater play vehicle in which my brothers (I was the second of four) and I spent many happy hours and days.

Dad built makeshift tents in the garden for us to play in, but the big step forward was a rambling toy fort with turrets and crenellations made from packing cases. He coated the walls in glue, sprinkled sawdust over them and painted over this with representations of stones, ivy and camouflage. From bits of nothing he made entire new worlds that expanded and enriched our lives. (Figure 2.1)

We moved home six times during my childhood, and each time we arrived somewhere new my dad went about fitting shelves, wallpapering and generally making the place unique and personal, created by us for us – or so it seemed. None of this was spectacular innovation – it's what parents do all the time for their children – but for me, the possibilities of making worlds was born, and grew, and lasted throughout my life. Our first move was almost immediately after the war had finished, when the Labour Welfare State revolution began. The Ministry of Pensions and National Insurance was set up in Long Benton, Newcastle, and my father was promoted to work in its new offices in the hastily erected prefabs there. My family moved from Manchester to Newcastle, which I always thereafter considered to be my home town, as I lived there from the age of eight to 23. My father stayed for six months in the Rex Hotel in Whitley Bay, and it all seemed to me a glamorous life in prospect and full of possibilities. (Figure 2.2)

In terms of my father's work, the National Health Service, education reforms and the Welfare State generally, the Labour Party and the aftermath of the war affected our working-class lives fundamentally. I spent my entire childhood with food rationing, as I was born just before war broke out and rationing didn't end in the UK until 1954, when I was 16 years old. But I now benefited from better healthcare (I remember receiving free dental care, in stark contrast to my parents, who had had false teeth from their late twenties), and better education (with the eleven-plus exam dominating many families' lives).

Newcastle was a total and enormously stimulating change of environment: we moved from a suburban/urban environment to the edge of the countryside, into social housing prefabs on an estate that was being built all around us. I grew up on a vast building site! We were housed on the first street of five houses to be finished off, on a site that grew eventually to 2,000 homes. It was a very open social housing estate with kids roaming freely across it into the countryside beyond – not gangs in the modern sense, but not far off it.

At primary school I was a serious under-achiever; I learned not to try at school. This might have been influenced by an experience I had at entry level, at five years old (in 1943). My elder brother had reassured me by raising my expectations, saying that the entry class had rocking horses, toy cars and so on, and that it was all going to be great fun. However, when they tested me on reading skills on the first day, the teachers decided to put me in the class above, a lesson I never forgot – that succeeding academically deprived me of playtime and my own interests.

However, what I now realise is that I integrated into my life and experiences many things, instinctively paralleling lots of the apparent benefits of a private school system, but in a modest, personal and untaught way. If you look at the prospectuses of Harrow, Eton, Winchester, Marlborough and so on, they all claim that they will cultivate leadership, self-reliance and confidence; building character and a sense of belonging, educating skilled communicators. I started life unknowingly forming many of these emergent skills for myself, and invariably on my own. These are the foundations of eventual relative success that I was subconsciously constructing – but I did not know it at the time. I was unwittingly doing some of what was needed to prepare myself to compete with these privately educated children in later life, under the class system in Britain that intensely disadvantages children from my background.

One of my first realisations of this was while independently building a huge bonfire for Guy Fawkes in 1947, when I was nine. In Manchester we had been a close-knit family, but my elder brother experienced the move to the Newcastle Grange Estate in terms of his apparent realisation that there were bigger boys that he could join, and that abandoning his younger brothers, particularly me, was the way to go. (In fairness to him, he was much taller and physically stronger than me at this stage – I was to prove a very late developer!) So he excluded me from the gang building a bonfire on communal ground in front of our estate. I reacted by getting together all the younger boys and my two younger brothers to build a bigger bonfire, almost three metres high, through commitment and hard work. By gathering together the perceived 'rejects' – the smaller and younger boys – and organising them to make something bigger and better, I understood something that became a pattern throughout my life.

In that year I had moved primary schools from Coxlodge to St Charles's in Gosforth. At lunchtime, after the children had eaten, they were kept outside in the playground for nearly an hour – and this was a time with very limited supervision from teachers, so extensive bullying took place. Although it was a primary school (five to 11 years) it was also a secondary school (11 years upwards) for those who didn't go on to the secondary modern or grammar school, and perhaps this group saw themselves as rejects. It was a very hostile environment for me. My mother gave me and my brothers the money for school dinners (which was collected on a Monday, a week in advance) and I noticed that some of the children who lived nearby opted out and volunteered that they did not have dinner money as they were going home for lunch. So I devised a scheme, which I kept going for several terms, where I said I was going home for lunch, but kept the money my mother had given me. For this period, during the lunch break, I went to buy a sandwich and crisps and sweets from the shop and walked around town – so budgeting and independence came at a young age. It was, I considered, a successful ploy as it meant I avoided the bullies and it gave me the freedom to do my own thing.

At school I went on to form 'The Scraps', of which I was always captain – a team separate and apart from the two football teams of 22, which comprised the leftovers from a class of over 30 pupils. I was then free to do what I liked with these 'rejects', or 'scraps' as they were derisorily called by the sports master, and I led them to athletics, gymnastics and the Highland games – as well as, of course, football. We became a multi-skilled unit, I liked to believe.

I also reacted against camping with the Boy Scouts. My first trip with the Boy Scouts was at the age of ten: I hated it, I hated the organisation, I hated tying knots, I hated the tribes and all the ridiculous false military language and hierarchies in a quasi-institutionalised environment. I never agreed with all that, and the second time I went with them a year later, for which we were 'volunteered' by my mother, I think, to get us out of the house, we went to Wooler, where I loved the valleys and the Cheviot Mountains but hated the tented encampment with the other scouts. There was a big storm on the first night and our tent was ripped apart, and we ended up being shuffled into sharing a very crowded tent with other boys. There was some debate in the morning about what to do with the damaged tent. It was suggested that it be thrown away, but I asked if I could have it. So I immediately and independently got the bus home; my mother, I remember, was very disappointed that I had returned early (my brothers stayed on the trip), as she thought she had got rid of us all for a week! But I managed to persuade her to sew a huge long patch on the tent using an old raincoat – and with my father's help I studied how to waterproof the seams and joints, and this got me into the camping business! So, aged twelve, I persuaded my parents to let me take one of my younger brothers and three other classmates on a week's camping holiday to Seaton Sluice on the Northumberland coast. We stayed in the sand dunes there, and this got me really fired up to organise more holidays for myself and other boys. I then arranged camping in the same tent many times around Northumberland and County Durham; I remember us telling ghost stories at night and organising mock Olympic Games in the farmer's fields in Wylam. As I got older I moved on to organising youth hostelling, walking in the Cheviots and cycling trips – two of us went all around Scotland on a tandem.

This kept on right through my school years until I was 16. I continued to build huge bonfires every year on Bonfire Night, and I organised my brothers and the younger boys on the estate to form a nature club, giving shape and form to the experience of the countryside that we lived in. I also collected pets – rabbits, guinea pigs, tropical fish – and traded them.

There were two components to this realisation of the fulfilment of leadership: one was rejection or disillusionment with the established way of doing things, and the other was coming to understand that the results of collective teamwork and resilience could be enhancing and rewarding in any endeavour. These were fundamental life lessons, perhaps learned unconsciously at the time. Along with this was a growing consciousness that, during those times of rationing and, when I look back at it, hardship and deprivation – although nothing like my great-grandfather had experienced emigrating from Ireland to Manchester and in the wars – I enjoyed the rewards of self-reliance, and it became second nature to me.

I've always also been interested in 'gleaning' – the practice where after the crops had been gathered, the populace was free to scour for leftovers. I started off in the potato fields on one occasion when I was about nine years old, and ended up in a magistrate's court in Newcastle, as the farmer, unknown to us, hadn't finished harvesting the crop. We were acquitted but it embedded in me the knowledge that everything has a value, just as the 'scraps' and 'rejects' in the school football team led to recycling the tent and on to refurbishment of buildings and eventually streets and

neighbourhoods and whole cities. It subconsciously reinforced the self-reliance and indeed the potential of recycling and constant change.

From the age of about ten to 17, I delivered newspapers for Harry Eblett's on the Gosforth North Road. This earned me the money to pay for my various hobbies and camping trips, as my ambitions in this direction grew. All this was rooted in the realisation that freedom was linked to financial independence. I took on more paper rounds, so that by the time I was 16 I was often doing one morning and two evening rounds a day.

My paper rounds enabled me to observe, first hand, social differences and the effects of the class system in daily life. None of the council estate houses had private front gardens, and the doors were uniformly green. Flats had letters and numbers, so I would deliver to 17a or 6g, for example. On the next rung up the social ladder were the tree-lined older (pre-estate) streets where privately owned houses had enclosed front gardens with garden gates, 'Beware of the dog' signs and side doors for tradesmen, and where house numbers were often less favoured than names such as 'Sunnyhills' and 'Heatherlands'. At the top of the social scale was 'The Grove' in central Gosforth, which, in common with adjacent streets in this exalted neighbourhood, had driveways, brick-built garages, front lawns and house names starting with 'The': 'The Elms', 'The Beeches' and so on. Each social group read different newspapers. The tabloids, women's weeklies and comics went to the first group; the *Radio Times*, *News Chronicle* and *Guardian* to the second; and *The Times* and *Daily Telegraph* to the third. I could have written an excellent report on the social profiles of different classes and their reading habits just from the perspective of a paper boy. Here was a community where placemaking was expressed in so many different ways that made its members' aspirations and sense of belonging visible. Just as animal and aquatic species – gulls, rabbits and fish – have their habitats, so do human groups each have their own territory within their different houses, streets and neighbourhoods.

* * *

Underpinning most things is the gift of energy, which, like communication, is something you tend to have from birth. In my early years I ran and ran, as I was super-energised. My parents entered me for a race for ten-year-olds at the Hoppings – a wondrous annual temporary fair on the Newcastle Town Moor. We arrived too late for the race but I was gripped by this temporary city – a miracle of instant placemaking populated by gypsies, fairground people with tethered horses, pet dogs and children, and entire families engaged in a life together. Perhaps it was the influence of the travelling Celts and tinkers of Ireland among my ancestors, but I was much impressed that this was a city made by the hands of the very people I could see around me. It was magical with its bright colours, vibrant patterns, sounds of metallic organs, steam engines that worked the roundabouts, and hustling buskers who enticed you into their tents to see the 'fantastic' marvels within.

I soon lost my parents and walked on and on. After a few hours I realised I had to make a plan, so I kept enough money to buy a cinema ticket in Gosforth, over 3 km away. I half expected to meet the rest of my family in the cinema queue. Little did I

know that they were at the police station reporting me missing – fearing that, by now, I might be halfway to the Continent on the back of a gypsy caravan. But I went in to see *Bambi* and for the second time that day was overwhelmed by a visual fantasy world – this one created by draughtsmanship, colour images and animation. I had loved reading American comics during the war and *Bambi* seemed to take their frame-by-frame visual storytelling a momentous step further. It was without doubt one of the most wondrous moments of my childhood, sitting there in a dark cinema, on my own, watching this extraordinary creative explosion.

The great beauty of the early Disney films sprang from the fact that the Depression had so reduced labour costs that Disney's Hollywood academy could afford to employ armies of skilled, gifted, dedicated and innovative artists to handcraft feature animations. From a time of hardship came this creative outburst – but later, in 'better' times, the drawings became simplified and over-stylised because of the high labour costs (although computers have given us back this graphic fluency at relatively low cost). Needless to say my day of delight and discovery ended with a bump when I got home to a family not the least bit interested in my marvellous experiences.

Given my northern postwar upbringing on a newly built council estate, the world of Walt Disney at that time offered a cultural liberation quite distinct from that provided by stilted black-and-white movies, particularly British-made ones, where actors spoke in cut-glass accents just like the radio newsreaders. Disney kindled my interest in popular culture, as well as showing me that the real ability of the artist is not merely in painting or sculpting objects for art galleries, but also in creating entirely new, accessible worlds from the imagination.

Years later, when I first went through the portals of Disneyland Los Angeles with my children, I was struck by the words of welcome: 'Here you leave the real world behind.' Disneyland represented a link, a transformation from the celluloid film world to the fantasy of the funfair, yet on a scale that – in respect of its industry, business organisation and ambition – the world had never seen before. In retrospect, Disneyland makes the family tents and caravans of traditional fairs like the Hoppings seem like quaintly modest, haphazard survivors of a much earlier age.

*　*　*

By September 1949, to my parents' and teachers' surprise, I had passed the eleven-plus and been selected to go on to St Cuthbert's Roman Catholic grammar school (now a comprehensive), which was thought to be midway between a secondary modern and a private school. I didn't enjoy it there at all. We were divided into three streams – A, B and C – where the As were expected to go on to university, the Bs would become the apprentices and the likes of road and telephone engineers, and the Cs were hopelessly forgotten about, and would become manual workers, like their fathers. I therefore ended the 1940s in a less-than distinguished school career where I was always hovering at the back end of the Bs and about to be relegated to the Cs, but luckily never was. In fact the social gaps were too big, and even the top of the A stream didn't get into Oxbridge: despite their best endeavours, that seemed an ambition too far. The streaming system offered some hope of a way out; but it was a much greater order of

change that was needed, as its promise of social mobility was an illusion for many, and to succeed came at a higher cost than ever was anticipated. (Figure 2.3)

Confidence was and is one of the attributes cultivated by the outstanding private schools, and I took some time to realise what it was. It wasn't until later, when I was 15 or 16, that I developed sufficient confidence to begin to prevail. But skills as a communicator are among the other assets bestowed by a private education, and to some extent these are innate: although they can be developed and nurtured, I believe something has to be there from the start. Communication is an interesting characteristic – from a very small child I was able to talk, and my parents nicknamed me 'Horace' after a radio programme as, like Horace, I gabbled away energetically and my elder brother had to interpret what I was saying to my parents. And so I was known to be talkative at this early age, and I went on to tell stories and to be chief storyteller on our camping holidays. I loved English Literature (and reading short stories), a subject which was one of my few successes at grammar school.

The 1950s

In 1950 I was 12 and on the cusp of becoming a teenager. I was really enjoying the freedom I had on the estate north of Gosforth, from where I often cycled to the coastal town of Blyth in the summer, when the days were brighter for longer. I enjoyed solo cycle visits to Gosforth Park and to Seaton Delaval Hall, Sir John Vanbrugh's early-18th-century masterpiece. I went sea fishing on my own, all day long, which seemed like – and indeed was – a great adventure at that age. My life revolved around being outdoors and I enjoyed it immensely. I remember it as a time of personal discovery, enjoyment and freedom.

But for me school was the opposite: there, I felt suppressed. I wasn't conscious of making defining decisions during that period, but I definitely did, subconsciously – the first and most singular one being that conventional schooling was not for me, so I opted out of the system. I didn't recognise or accept it, or consider that it benefited me at all. I was unmotivated and absent. I resigned myself stoically to not being noticed, and this meant me not trying, and under-achieving, since the most I aspired to was to be invisible. I was obviously spectacularly successful in this endeavour, as year after year my school reports contained just three words: 'lazy in effort' (a comment with hindsight that said as much about the teachers as it did about me!). The sole exception was when at the end of my first term, just before Christmas 1949, my art master (whom I learned to admire) singled me out and praised a painting I had done of the Cheviots. He showed it to the whole class and encouraged me, saying that I had a promising career in art ahead of me. (Figure 3.1)

The reason I liked art was that it was something I could do at home in the evenings, weekends and school holidays. This was the other element of my subconscious choices – I chose to invest as much energy, thought and time as possible into out-of-school activities. I lived for the time outside of school – a degree of choice and level of freedom I wouldn't have had at a boarding school, whatever the advantages of such a private education might have been in other respects. I enjoyed spending time at the local Ouseburn River, away from all school and family pressures. I had found a reason for living. I organised camping and youth hostelling trips during the school holidays, and went walking in the Cheviots and along the Roman Wall. And I also joined the Gosforth Harriers, and ran all around that part of Gosforth and Northumberland, including Gosforth Park, Heaton, Fenham and Benton. I didn't like the races, I just loved the running. I bred tropical fish and mice and guinea pigs. My father helped me make cages and boxes for them, and assemble fish tanks and stands for the tropical fish with oil heaters beneath.

My father helped me a lot with my hobbies, and my mother seized on this: as I was getting older, when I had to choose a career, she told me that it didn't matter what I did in the daytime as a job – for example, I could join the Civil Service and just pursue my hobbies in the evenings and at weekends. That immediately triggered a reaction in me. I didn't want to waste any of my life doing a job I didn't like. I wanted my hobbies to become what I did all day (as well as weekends and evenings), so in January 1954, immediately after the New Year, when I would have been aged 15, I found myself in what became one of the most arresting and decisive moments of my life. I was sitting in a classroom presided over by Father Cassidy, the form master of 5B, and he went round the class enquiring what we all intended to do when we left school. When it was my turn I said I wanted to be an architect. He was a sarcastic and opinionated man, and he put me down and derided my choice: 'You'll never make it, you're bottom of the class' (that was true, I'd just come bottom of our B-stream class in the pre-Christmas exams). He said in front of the whole class that I would never make it at university and I should not even try to go into the sixth form, where I would be out of my depth.

The reason I had said architecture, rather than an art/painting career, was down to a spell slightly earlier in the previous term when I'd been off school because I was suffering from facial eczema, which crucified me in those days. A rainy day stopped me from going outside to draw trees in nature, and I was looking for something to draw instead, and settled on drawing the houses in the street opposite, looking out at them through the window. My mother saw this and took the opportunity to influence me, saying: 'Why don't you become an architect rather than a painter?' At the time she was trying to steer me towards a regular job. Now, at virtually the same time, Father Cassidy was telling me that this door was also closed. And so I realised pretty much immediately that I had really messed things up, as there were only six months to go until the O-level exams (the equivalent of today's GCSEs) and I had to pass six of them to have a chance at getting into the sixth form and being an architect.

So for the first time in my life I began to study, and I not only studied art and all the other subjects, but also exam techniques. I discovered to my astonishment that I loved examinations – for me they were a challenge I could relish. I enjoyed having invented a revision system and being put to the test under time constraints and writing quickly.

I wrote pages and pages in the exams. And so by the time of the in-house exams the following summer I had transformed from being bottom of the class at Christmas to near the top in most subjects, and then I passed eight O levels with good grades – a total turnaround in only six months!

Immediately after the O levels, my art master Maurice McPartlan organised for me to work in the office of the architect Edward Gunning in Eldon Square in the centre of Newcastle, which confirmed to me absolutely that my chosen career as an architect was the correct one, in terms of my skillset, interests and the creativity it offered. It seemed to me that it married art, organisation and spatial construction skills that were matched to my own, but I wasn't at all aware that it was a somewhat elitist profession I was aiming to join.

Several other accelerating dramas also happened during that busy summer of 1954. The first was that my art teacher entered me for a drawing award from the Northern Architectural Association, for which I won first prize and received £3. (Figure 3.2) The second was a success in my running, when I won the school mile. And then came the third, which was more challenging: my form master and deputy head of the school, Father Cassidy, repeated to my parents what he had already announced in the classroom – that I wasn't sixth-form material, and that I 'wouldn't cope' with the challenges of university. This last event, of course, devastated me; my father went to see Father Cassidy, and my father's subservient respectfulness and submission to the Catholic Church (mentioned earlier) apparently surfaced in that meeting. He reported to me afterwards that, regrettably, Father Cassidy was most likely right, and that instead of attempting to go to university, I should probably take the Civil Service exam or choose another career. But my art master Maurice McPartlan, to whom I owe a huge amount of thanks, persevered with my candidature for sixth form. As it was explained to me, this meant providing singular evidence of my suitability, since St Cuthbert's, as a Catholic school, had to pay towards my sixth-form education. With his encouragement, I refused to give up, and applied for sixth form; championed by him, I was provisionally accepted subject to the following Christmas exam results. (Figure 3.3)

<center>* * *</center>

I loved the sixth form, it was a revelation, and I worked away happily with just three subjects to concentrate on – Art, English and History. I loved being mixed with the A-stream boys, in very small classes, and no longer having the stipulation of a school uniform. And to increase the effect of non-regimentation, we were peripatetically housed in the school house attached to the main school, which was informal and relaxed, not being geographically limited and not bound by a classroom. I flourished and really found myself in this environment.

I've thought since about why that was. A conversation many years later with the architect Ted Cullinan was enlightening on that front. He went to the private school Ampleforth College, and we discussed our Catholic backgrounds and were each surprised when we found out how differently our priests interpreted and applied the confessional – such a key part of Catholic doctrine, and something that pervaded my

life. I said that the act of confession was a way of keeping Catholics under control. His reply, that it was liberating, really surprised me. He went on to explain how he had been taught that confession is a normal part of life, because committing sins is a normal aspect of being human, and so to view sin as unavoidable is to commit the sin of arrogance. I probed and found out that he had enjoyed a relaxed relationship with his priests/teachers, which acknowledged that we and they were together in the same boat. My observation was that class division came into it, and that the regimentation and the different experiences came from a distinction between the officer class of those at the likes of Ampleforth College, and the lower-class children at my school, where control and suppression was the primary aim. In a way, I reflected, I had begun the process of joining the officer class in the sixth form of my school, alongside the A-stream sons of teachers, even headmasters and in some cases the professional classes where the main aim of the teaching staff was to nurture rather than to control or suppress. I'd been elevated beyond the masses, the army of mere troops that required leading and controlling.

What was sad, looking back on that period, was that I felt alienated from both of my parents. I had gone on camping holidays with my father, including down to London to visit the Festival of Britain, camping at Crystal Palace in 1951, and he had helped me with so many of my interests and hobbies. He introduced me to making things with my hands. But things were different from that point on. (Figure 3.4)

* * *

So, from starting off as a loner and academic disaster at school, then flourishing in the freedom of sixth form, I passed my A levels and got into Newcastle University in 1956. My parents had by this time moved to Blackpool, on the opposite coast; all my brothers were soon dispersed, pursuing careers in different parts of the country. All my life I had shared a bedroom, and the double bed within it, with my brothers. And so I stayed on my own, defiantly, in Newcastle. I felt that the university's school of architecture offered me a tremendous amount of positivity and optimism. I had succeeded in my mission to get into university. But this, I soon realised, was just another step on the way; it was merely a foothill of the mountain I had to climb – the top of which, in the far distance, I couldn't yet see. And it was up to me to figure out how to prevail.

I started off with ideas for tremendous overly expressed independence. I thought of buying a caravan to live in, but then slowly realised this would be too isolated a life. I had costed it right through and considered it seriously but saw that I was over-stating my assertion of freedom and being on my own. I bought bright clothing, which I later dyed dark, as I realised the possibilities of the new life I had found needed to be controlled and tempered. I had taken temporary digs (a sort of B&B in Gateshead) with a Catholic family that the parish priest had recommended – I was determined to live away from the college halls of residence or flat sharing, and I wanted to express my complete independence of all institutions.

But my biggest and most life-changing moment came one night in November of 1956 when I was working late. For the first time in my life I suffered anxiety and a panic attack. Could I cope with this life? It became a demanding and overriding question. I

had set so many targets: I was going to be the best architect at the school, I was going to wear my own clothes my own way, I was to live independently. Most of the anxiety and panic was centred on my parents' reaction, and I slowly realised that separation and being on my own was a major challenge. The very idea of my parents having me back home because I'd had a nervous breakdown haunted me. A nervous breakdown was, to my mind, a gradual and irrevocable downward slide to madness and being locked up in a lunatic asylum, which was an all-too-real possibility at this time, as these institutions were still operational. Amid the war reparations in the mid-1950s my father worked on insurance claims from old soldiers and used to recount to me the terrible things that happened in such asylums. Obviously my active imagination fed this information into a fear that at times drove my intense, crippling anxiety and panic attacks. On reflection, I was separated from everything familiar due to the onward and upward personal march through levels of privilege, from sixth form on to university and hopefully beyond. I was facing the very thing I'd spent my early life avoiding, in that I had to face the choices I'd made to compete. This was a race, not training.

I often read these days about emotional problems among students at university, but back then I didn't know of anyone who had suffered similarly and I decided that the only thing was to cope, hide my feelings and bash onwards. The realisation that I was leaving behind my family and its values is described brilliantly by David Kynaston in his survey of the 1950s and the effects of grammar schools in terms of alienation of the successful students from their original families: 'Unfortunately for every real-life Billy Elliot ... there were many, many mute inglorious Miltons ... The child expands and the family cannot cope.'[6]

As I mentioned at the start of this book, my maternal grandfather, Jim Maguire – a man who wasn't fearful of life – welcomed my progress, and marked the occasion of my getting into university by giving me a briefcase with my initials embossed on it. My parents were much less enthusiastic about the path I was taking, and transferred their anxiety on to me. My mother told me in no uncertain terms that some of the ideas I had were above my station and that, in her fateful words, I 'would have a nervous breakdown' – just as she had at the same age when faced with the pressures of career success. She had surrendered, albeit in different times and circumstances; but I had decided that wasn't the course for me. I would stick with it, be less expansive and less ambitious socially, and concentrate solely on the task in hand. By closing down my distractions and immersing myself in ruthlessly competing on a narrowly focused front, I would make sure that I succeeded in the one thing that mattered most, which was my studies at architectural school. So, as the years passed, I was able to show that I was prevailing as a student, and as a promising nascent architect. I ended the final year proving myself as such with a first-class honours degree.

I felt I had to adopt a stance of becoming unbelievably motivated to justify my choice to my family, my peers and my old and new teachers. All this was based on a belief in myself. I did not know where it came from or where it would ultimately lead, but I knew I had to follow it. I focused on emulating major successful architects – absent 'mentors', as it were, like Frank Lloyd Wright, and eventually Buckminster Fuller, whom I discovered only in my final year. They were very independent architects away from the European traditions; we in the North were influenced more by

Americans than Europeans – I was never a believer in the Bauhaus or Le Corbusier. Unwittingly I had been attracted by the much-admired stereotype of the 'creative individual manifesting his will in action', as described by Andrew Saint in his book *The Image of the Architect*.[7] It was probably a result of my having had little contact with contradiction, competition or wider reality, which a broader base would no doubt have facilitated. The ideal mentor at this lonely stage in my life was the robust heroic individualist, much praised and idolised in America. The price paid by all those around Frank Lloyd Wright, Bucky Fuller and Louis Kahn wasn't yet evident to me. I honed my drawing skills and became very accomplished at visual presentations. I experimented with different influences, but finally ended up as a fully committed High-Tech architect – several years before the term was invented – and all of this was done independently, on my own, in the far northeast of England. I based my final-year design thesis on Bucky Fuller's work, and I even named it 'Climatron', a word that he had coined for a greenhouse in the form of a geodesic dome. But it was unique to me that I thought of the wider town-planning considerations of the Blackpool Tower and the promenade from which it sprang, and did a cost–benefit analysis to justify the overall economics of the entire venture – estimating ticket sales against building costs along the way. (Figures 3.5 and 3.6)

Looking back on my portfolio of work, the major impression is of a student who drew and painted with fluency and dexterity and experimented with many different styles of architecture, as well as one who had a growing attachment to history and the bigger town-planning environment.

* * *

It was important to me that I always handled myself efficiently and successfully in terms of my personal finances, which fuelled my progress. I got £5 per week during term time (£150 per year). I worked at Blackpool during the summer holidays, where there were an abundance of temporary employment opportunities at holiday camps, bars, the Pier and so on. Later, in my fourth year, I found placements at architectural practices in local offices in Newcastle during the Easter and Christmas breaks. Alongside all this, my personal life became settled and I found in Rosemarie – my first wife, whom I married during my final year at university – a really great and loving companion, and in her mother and family a home-from-home. My mother said 'We have lost our Terry to Rosie's family' – which was probably true to some extent. (Figure 3.7)

So the 1950s ended, and by December 1960 I was married, having enjoyed a successful student career and become, I thought, a high-achiever. At the end of every academic year I had lined up an architectural prize which enabled me to survive, have an income and travel. I had also broken my leg in a motorbike accident in 1958, for which I received £180 in compensation from the lorry driver. Continuing to follow the embedded entrepreneurial instincts that I'd developed in my childhood, I put this sum down as a deposit for a mortgage – and so, while still a student in the fourth year, was able to finance the purchase of a house in the village of Ryton in County Durham,

which I sub-let to medical and architectural students. I ended up selling it at a 30% profit to relocate to London and start the next chapter of my career.

I felt that I had talent, and this was confirmed by the university selecting me for awards. But I didn't think I was academic or intelligent. I made a separation between talent, or a knack, and intelligence: I came from a background where many others had succeeded in athletics, football or pop music – like Brendan Foster, Alan Shearer (the latter brought up on the same housing estate as me) or Sting (who went to St Cuthbert's, which he refers to in his autobiography as 'Belsen') – and all of them had a knack or skill and were successful, as I saw it, purely because of that innate gift of talent, rather than intelligence. I really felt that I had separated the two out in my mind. At that time, I wasn't someone who had a rounded view of life.

* * *

When I graduated in 1961, I didn't realise I was still on the foothills and had yet to face the many deprivations that came with the territory of growing up on 'the edge of the edge', and of being the first in my family to go to university. Nor had I grasped what that meant for my parents – and indeed my whole family, who didn't support my academic endeavours, with the notable exception of my grandfather. I felt that I was a prime example of the Welfare State's meritocracy, and had reached a position from which the world would welcome me. So I went to London to find a job, with money in my pocket from property sales, and a wife, and a degree in architecture. I felt I had comprehensively proved everyone wrong in their assessment of me. But I didn't realise at all how far I still had to go.

The 1960s

Many years after the timeframe of this chapter, as part of a sixth-form project on 'the city', my youngest daughter Milly created a tower of multiple pinball tables in which the numerous rolling silver balls made connections that lit up. Her proposition was that 'chance' – the rolling balls – was the key to the city, a place where you maximised your chances in life through the unplanned events that were intensified in large, mixed populations. This was certainly true of my experience after arriving in London in July 1961. The southward drift was an inevitable consequence of my education, which had raised my expectations as well as my skill levels. My primary intention was to get the one year's practical experience of working in an architect's office that I needed before I could apply to be a fully qualified RIBA architect, but coming to London at the end of my studies also offered opportunities for cultural events, lectures and talks, as well as chance encounters with possible future friends and working partners. Although London at that time was a place of great opportunity, the streets were not quite paved with gold. Yet they were larger, busier and more vibrant than anything I had known before because London is an immigrant city par excellence – built on trade and commerce, insatiably absorbing newcomers and their energies.

I slowly began to realise that succeeding in my university career was not enough – not by a long way. I had again come up against the class system at work. Other graduates with lower-class degrees got better offers in terms of jobs and salaries, or even immediate partnerships, because of their family contacts. I was, in fact, recognising and paralleling the phenomena described in the BBC television

documentary 'How to Break into the Elite'.[8] The programme focuses on the glass ceilings that exist to this day for high-achievers at university.

It was around this period that I began to explore the bit that I didn't have, albeit subliminally – in particular the social background of being an architect – and so I grew friendships with privately educated people from Newcastle who had also moved to London, like Peter Smith who was studying at The Courtauld at the time, and his friend John Smith (no relation) who had arrived in London a couple of years earlier. Initially I stayed at John's house in Primrose Hill, but soon began to immerse myself in the residential property market in London, which has preoccupied me for much of my life since. London, I soon found, was suffering from an intense housing shortage. Peter and I could afford a house together for about £2,000, which meant we had to accept what was called a sitting or protected tenancy as part of the purchase. We often saw whole families living in desperate poverty and squalor in one or two rooms. I was astonished by the sight of the crammed-in humanity living in the multi-occupancy houses we inspected on the fringes of Kentish Town and Camden Town. London, evidently a place of wealth and power, had at its wide edges a third world of *barrios* within and behind genteel facades, reinforcing in me that my grandfather's experiences, like those described by Tristram Hunt in *Building Jerusalem*, were just a misstep away.

* * *

My first contact with the realities of an architect's office after graduating from Newcastle was at London County Council, during the first six months of my year's practical experience. Initially I had had interviews with leading architects in the capital – Lyons, Israel & Ellis; Denys Lasdun; and Stirling & Gowan. Both Denys Lasdun and Stirling & Gowan were practising from beautiful houses in Regent's Park. Stirling & Gowan had no work at the time, but were happy to chat for what seemed like hours. Lasdun offered me a position, but it was on working drawings, and so in the end I chose a job with the LCC at County Hall, as it would provide me with more design opportunities.

I had been married to Rosemarie for six months by the summer of 1961, and she was on her way to London to join me, so there was pressure on me to find a job and a home for us both. Perhaps I chose the LCC also because, in my temporary insecurity, I was instinctively drawn to my family's safe Civil Service roots. But I soon found out it was not for me. I began to resent the office atmosphere and the formalities about who had which desk and which piece of carpet under their desk to signify their position in the bureaucratic hierarchy. Attaching great value to territory and personal domain can lead to uplifting places and great architecture – but, in communities where bureaucratic tribalism has destroyed positive working relationships, it can result in an obsessive concern with trivialities. The LCC had had a great impact on London (particularly in the form of the fine purpose-built flats and estates between the wars), but the city's own growth and eventual overblown loss of direction led to the abolition of its governmental body (the Greater London Council, or GLC) by central government in the mid-1980s. During my time at the LCC I saw many indications that the people

within the extensive group of buildings that comprised County Hall were not fully in control.

The LCC taught me valuable lessons about how a public body works and about the need for leadership and sound office management. 'What belongs to everyone belongs to no one' was a fact of life that I had recognised as a child on a council estate, and I felt that it applied to the LCC architecturally. Nobody took overall responsibility for very much, and as a result there were a few maverick entrepreneurs who were able to take advantage of the leadership void and set about designing and building their own projects. Some innovative and some rogue projects got through the system and were built – which gave certain individuals notoriety and often brought trouble on everyone else – but there was little that the general mass of employees, or the LCC, could do about it without fundamentally changing the structure of the organisation. I was struck by the risks architects took. People were experimenting with system housing and prefabrication – and with people's lives and their futures – without thorough testing of their ideas.

For the first few days at the LCC, the architect at the neighbouring desk said not a word to me, nor I to him. Eventually I mentioned my dissatisfaction with the organisation of the office, and he expressed his sympathy and suggested we talk over lunch. That marked the beginning of my close friendship with Nicholas Grimshaw. Together we formed a maverick but pretty insignificant unit within the vast bureaucratic set-up of this local government organisation. Nick was working on the Crystal Palace recreation ground, while I was given a job of my own: the Blackwall Tunnel buildings, which engaged me with the Thames, a new river crossing and the renewal of East London. (Figure 4.1)

When I took the tube out to Blackwall, I had no idea where I was going. I wandered around this desolate no-man's-land and tried to imagine that someday there would be new tunnels and roads there. This was a few years before the building nearby of Ernő Goldfinger's Balfron Tower flats and Peter and Alison Smithson's Robin Hood Gardens, and long before that of Cesar Pelli's Canary Wharf Tower and Richard Rogers's Reuters Data Centre and Millennium Dome (in the 1980s and 1990s). My remit included the linings of the tunnels, and this involved studying how best to use colour within and without, and the choice of tunnel cladding materials. But the task of designing the ventilation or fan buildings, and a supervisor's office, and the point where the old and new tunnels met gave me a chance to create real new buildings and do it virtually on my own. The fan buildings as they evolved were fairly innovative. It turned out that there were engineers at the LCC who were interested in spray concrete and facilitating the realisation of freeform shapes, and I took full advantage of their knowledge and enthusiasm – I had become a one-man entrepreneur hidden or lost within the system. Blackwall felt like the middle of nowhere in 1961, in time as well as place. Still suffering the aftermath of the heavy bombing of the London docks during the Second World War, it was in a kind of limbo, a silent no-place awaiting its fate. In the subsequent 50 or so years it has seen prestigious new development, epitomised by the Millennium Dome (now the O2), built around Blackwall Tunnel's southern ventilation building. In 2001, both ventilation buildings were listed Grade II, as being of historical interest.

Nick had been to Wellington College in Berkshire, one of the country's most

prestigious boarding schools, but I felt a connection, that there were bridges I could build with him; he had suffered a debilitating illness, made an initial wrong choice of career, and his father had died when he was young. And he surprised me by announcing that he had, like me, hated school. All of which meant he did not accept the hand he had been dealt, and so he and I formed a close friendship very early on when I arrived in London. It was a friendship that continued for the next 20 years. While at the LCC we always had lunch together at The Cut or went into the West End across the Thames from our offices. I developed with him a more detached view of the social barriers to progress, and I felt closer to him than I had been to any of my classmates or brothers or family. Because he was a year younger, had missed school through illness and had changed career from engineering to architecture, he was behind me educationally, so I helped him get organised. He obviously saw advantages in me, in that I had a successful student career and I was an ambitious, very practical and pragmatic person when it came to overcoming life's various problems.

Nick was accepted by the Architectural Association and I went away to the University of Pennsylvania in America on a Harkness Fellowship. The Harkness interview, the awarding of a fellowship and the trip to New York on the *Queen Mary* were all hugely formative experiences that contributed to my adjustment to the highly competitive social world I had entered. When I came to London from Newcastle I was naive; I didn't appreciate how far I had to go, but I quickly began to compensate for that. On board the *Queen Mary* with all the other Harkness Fellows, I soon realised the social classes were divided not only on the ship but also between us as Fellows. The Oxbridge lot of students were a world apart – yet here was I rubbing shoulders with them. I had achieved a lot and taken another privileged step forward. My school, St Cuthbert's Grammar, had not had an Oxbridge candidate accepted for many years, and boys that I considered brilliant were still rejected, so I had formed the view that Oxbridge must be full of geniuses! But gradually the truth dawned on me, that they were fortunate in their background and the schools they had attended. Before I left London I went to the opera, art galleries, exhibitions, arthouse cinemas where I saw Buñuel and Bergman films, and concerts with Peter Smith. I really absorbed and began to become aware of differences and aspirations, and indeed barriers to aspiration.

* * *

At the University of Pennsylvania, where I studied for two years, I had an altogether different experience from London. It was assumed that I was super-clever as I was there on a Harkness Fellowship, and the English were outside of the US class system. Being at Penn meant I was already in a privileged part of the map of social structure at an Ivy League school. I used the time to develop myself intellectually rather than competing as part of the system. Indeed, I didn't need the system: when I had asked the secretary of the Harkness Fellowship whether the University of Pennsylvania would accept me, as I had yet to go through the application procedure, she had advised me simply to 'write them a one-line letter saying you have chosen them and that you are coming'. I'd never realised that being a Harkness Fellow would come with such

advantages. It was of an altogether different order, classifying me in the hierarchy of achievement. It opened doors – I was now becoming privileged, both socially and academically.

The early 1960s was an exciting, formative time in America. At Penn, teachers such as Paul Davidoff were campaigning for Civil Rights; Ian McHarg was campaigning for ecology and the environment; and Robert Venturi's book *Complexity and Contradiction in Architecture* was in gestation (although I was not aware of it then). Rachel Carson's *Silent Spring* had been published in 1962, a year after Jane Jacobs's *The Death and Life of Great American Cities*. Modernism – based as it was on a blind belief in the modern world – was questioned in America long before it was in Europe. This was a genuinely progressive culture compared with Britain, where the style of progress in the latter often seemed to matter more than the content, thereby preventing real change.

At Penn I had powerful teachers in a great institution of international standing, and I was surrounded by some exceptional students. It was not just an architecture school but also a graduate school of fine arts, with mixed disciplines, including town-planning, landscape architecture, architecture, sculpture and fine art. At the time, the urban design lecture courses were probably the best in the world, in that they brought together so many good people. However, I did not encounter much good urban 'designing' as such in the studio classes at the school, because the syllabus awkwardly combined a camp of planners and a camp of designers – and there was little connection between the students or even the teachers in the two camps. The designer/planner divide – as I have seen repeatedly throughout my working life – reduces the potential for collective and creative city-making by distancing from each other the two professions that are most actively involved in the process. At Penn – as elsewhere, I learned – however good the teachers were, it was generally left to the students themselves to synthesise these divisions.

Indeed the two cultures, of designers and planners, sat either side of us as urban designers. The former believed that all urban problems could be solved with more architecture and more intuitive, magical 'solutioneering'. The latter considered that three-dimensional design would somehow logically and almost mechanically materialise from proper analysis and understanding. Each camp relied on quite different skills, and during my entire career as an architect/urbanist, I have always found it difficult to bridge the gap between the camps. Urban planning is seen through two different pairs of spectacles, each of which reveals a different world, a different urban place. The really innovative pioneers, I felt, would be the bridge-builders who could bring Le Corbusier and Louis Kahn into the same territory as Jane Jacobs. Published in 1966, Venturi's *Complexity and Contradiction in Architecture* is still, even today, the most powerful, elegant and eloquent manifesto for a middle way: a human, balanced and integrated view.

The divide did not matter very much to me then because the individual departments and their lecture and studio courses were so good. Architecture comprised design studies with Louis Kahn and lectures by the likes of Venturi and Romaldo Giurgola. Very close at hand, on and around the university campus itself, were a number of recent modern masterpieces – Kahn's Medical Research Building; a student dormitory by Eero Saarinen; Geddes, Brecher, Qualls & Cunningham's

Philadelphia Police Headquarters; Frank Lloyd Wright's Beth Sholom Synagogue – and a wonderful fine arts library designed in the Arts and Crafts style by Frank Furness in the late 19th century. The Ivy League campus seemed to have as many traditional, leafy, brick-built quadrangles as a European university town, and the old arts building was a delightful and spacious Victorian construction. I was surrounded by architectural quality, but the real focus was Kahn's class. (Figure 4.2)

Louis Kahn was probably one of the best architectural teachers I have ever encountered. At Penn my interest in the use of architectural model-making took a new direction as a result of his teaching methods. He was a genuine educator who nurtured his students and was seriously intent on trying to understand them and bring them out. He taught three afternoons a week for four hours at a time. He would do no preparatory paperwork. Somebody else would choose the projects and write the briefs – he would simply turn up and look and talk. He would instruct us all to work in an identical way with clay models and line drawings, and he would then be able to compare students' work objectively, sometimes picking on the work of only two students in a whole afternoon and ignoring that of the rest of the class – a method I hadn't seen before and haven't seen since in an architectural school. He would merely place a student's model in front of him and talk about it, extrapolating generic lessons. He believed that everyone in the class could learn from only a couple of examples if there were a consistent and coherent teaching approach. The models we made had to be beautifully crafted and speak for themselves. By and large, Kahn did not encourage verbal presentation; his argument was that, when a building was finished, the architect would not be there to explain it – so he would stand in silence, sometimes for ages, looking at and studying the students' models or drawings. He would then open up and teach.

Kahn's work may have been highly architectural – it was what other architects thought architecture should be – but there was a powerful human side to him too. Despite his tough philosophical abstractedness, there was great discipline in his approach because his fundamentalism made him rigorously committed to seeking out the true nature of things. At its best, this method of teaching was profoundly moving. I was not one to adhere to anything that had an element of institutionalised religion about it, but I learned much from him. Most influential of all was the question in his teaching: 'What does your building/plan/city want to be?' I have often reflected that architects and urban designers have not only conventional clients to deal with but also their buildings' context and use – the places, our towns and cities, are our ultimate clients. Place leads. Place absorbs our results and, if successful, the new place adds and changes all life within it for the better. 'What does this place want to be?' became a mantra for me many decades later.

Kahn's openness to what things 'wanted to be' extended to a similarly open and tolerant manner towards his students, but ended up creating around him a world of blindly committed followers who drew, designed and thought as he did; all many of them 'wanted to be' was the master himself or a clone of him. I was fascinated, and also eventually worried, by the idea of an architect as a religious-leader type of figure, whose ideas were so persuasive and all-embracing that they had become for some a way of life, a total immersion in his world – for them, HE was the place. As far

as my own interactions with him were concerned, he approved of my resistance to a straitjacketed approach, but there was a tension between us, and I think he recognised that I was never going to be one of his disciples. My models were too impatiently made and not executed with the perfect precision shown by some of his other students. I saw his classes as a passing experiment for me, not a long-term commitment, and in the end I found his method too time-consuming and laborious. But the lessons I learned from making models with Kahn I have carried with me throughout my working life. In city planning he produced some fascinating conceptual drawings that abstracted the movements of cars, in a rather poetic way, with a desire to dig under the surface and grasp the fundamental nature of urban traffic movement. Taking inspiration from his drawings and those of Saul Steinberg, as well as from the paintings of Paul Klee, I doodled and sketched my thoughts about pedestrian crossings, about where people were in the sky, on the roads, even when enclosed in a vehicle. My thematically obsessive doodling (or 'Terrytoons', as my classmates called them) continued throughout my two years at Penn, enabling me to visually analyse ideas and perceptions of urban life and what it meant to me personally.

Among the other teachers at Penn, Paul Davidoff was a brilliant and inspirational leader who taught planning theory in a way that utterly contrasted with Kahn's studio. Davidoff's 'choice' theories centred on the re-inclusion of disempowered people in the process of city-hall decision-making. It was a revelation to me that city planning and local grass-roots politics could be seen as interdependent. John F. Kennedy was president at the time, and in Davidoff's class were lawyers and sociologists who were very active in the Civil Rights movement and in liberal politics. A fellow student was married to one of then vice president Hubert Humphrey's campaign team – and I found myself becoming politicised, albeit modestly, for the first time in my life. In Britain, I had found the Labour-versus-Tory debate at best petty, partisan and fairly meaningless, and at worst a way of distracting people from the real issues. But I had similarly found the communist-versus-capitalist posturing of my Newcastle student days far too ideologically abstract to be meaningful to real-life issues. At Penn, I became aware that good schools, good housing, ghettoisation and even bus routes were town-planning issues – and bad urban management and bad decisions about the physical arrangements of a place went hand in hand with disadvantage and poverty. In Britain, 'top down' was the essence of city-making, and I remembered that most people who lived on our Newcastle council estate were at the bottom looking up, and that they felt helpless to do much about it.

David Crane, a visiting lecturer, and David Wallace, our civic-design professor, introduced me to what might today be called mixed-economy or public/private town-planning. Crane's 'capital web' theory relied on public investment initiatives to generate private investment. In Britain at the time there was no acknowledgement that the private sector might have a role in town-planning. All UK planning involved public funds, and large-scale public ownership and control of land. When it came to new towns, greenfield universities and transport infrastructure, an autocratic paternalism held sway. But at Penn, Wallace, a planning practitioner, was in a private practice partnership with Ian McHarg, and the latter's impassioned campaign for an ecological approach to the environment was well ahead of its time. I particularly

enjoyed a project that involved measuring, in a mere few weeks, the entire ecological balance – climate, inputs and outputs of air, water and just about anything else – in the Philadelphia metropolis. No doubt it was scientifically pretty unsophisticated, even quite inadequate, but educationally it hit the mark for us all, particularly since the teacher himself encountered reality in the world beyond academia, in broadcasting, advocacy and the planning of real towns and cities. The quality of the teachers and teaching was captured very well for me in a booklet I later found on a symposium held back in 1963, which lists impressive contributors including Edmund Bacon, David Crane, August Heckscher, Lewis Mumford, Robert Venturi and Ian McHarg.

A good friend and tutor was Denise Scott Brown, and through her I met Robert Venturi, her future husband. She was outwardly intense but surprisingly humorous, as well as being a committed and serious teacher. From her time in London, Denise was used to British irreverence – I think she saw me as someone who was getting more out of being in America than simply the courses and teaching, which was probably true. I remember her comment that she could always tell the difference between British students who had returned home from the USA and those who had stayed – something along the lines of: 'The ones that go back home have spent their time immersed in American life, speaking mid-Atlantic, wearing trainers and Bermuda shorts, going to baseball matches and driving Chevrolets; the ones that stay exaggerate their Englishness, their accents become more like stage English, their clothes more traditional, and they capitalise on their situation by making a career from the American interest in things British.' (Figure 4.3)

Pennsylvania was at the forefront of urban regeneration, and its renaissance was spearheaded by the city's energetic chief planner, Ed Bacon, who taught classes and gave crits to the urban designers. Under Bacon's plans, I.M. Pei built a new residential quarter in the city centre that was beautifully considered and detailed and, most importantly, part of a deliberate piece of urban renewal in a historic quarter. It seemed ironic that the Americans, with their relatively short history, were leading Britain in city placemaking through historical continuity. In Britain, conservation movements were seen as the enemy rather than as a critical component of planning, placemaking and architectural creativity. It was no doubt my experience in Philadelphia that led me in the early 1980s to be one of the few British architects who resolutely built new buildings at the same time as being very active in the SAVE Britain's Heritage campaign to preserve the country's architectural heritage, and in committee work at English Heritage (now Historic England), the public body that champions and protects England's historic places.

It gradually dawned on me that Britain was not a democracy in the same way that the USA was, and I became very critical of the British political system. Living in Philadelphia, the birthplace of the 1776 Declaration of Independence and the new nation, I could not help but be aware that the structure and form of government of the USA was created there. The division of powers, the constitution and its public accessibility and transparency, the organisation of elected houses, all had an order and logic, a kind of 'architecture' that I could readily comprehend.

It was a fact not lost on me that among the great men who debated and drew up the new order – Benjamin Franklin, George Washington, John Adams – was a fine

architect, Thomas Jefferson (later third president of the USA). In the city plans they made for Philadelphia and Washington there was physical urban placemaking, architectural edifices with explicit symbolism that harmonised with the political structures they created. The fine written words and places reinforced with clarity what they collectively had made for the government of the nation. I looked back at Britain and regarded its lack of a constitution as a means of dividing and confusing society. The workings of government were at best opaque and at worst the result of deliberate secrecy, which meant that none of us knew how to take control of our own lives. I looked back at the town-planning and architecture of a city where all the great avenues led to the monarch's home, Buckingham Palace – yet the power was not there, but hidden in a Georgian terraced house in the tiny side street that is Downing Street. The unplanned confusion of London's palaces, government buildings and Houses of Parliament gives visual expression to the maze-like structure of our political world. Jefferson and his contemporaries played the role of placemakers at the highest level, helping to plan a nation and its cities and buildings on the grandest of scales and with great effectiveness.

The relationship between individual states, the buildings for senators and congressmen in Washington, and the fixed terms and fixed geographical requirements for candidates is part of the American conception of place – and place of this scale was clearly seen as requiring a mental map that everyone could grasp. In Britain, the confusion about the role of our government buildings in London's plan form, changing political boundaries, and particularly the peripatetic life of candidates who can be shunted around the country to 'safe seats', all add up to a disconnected and disorientating collective sense of what the UK really is in democratic terms. I remember trying to explain to my Democratic Party friends in the 1960s why in Britain, home of the 'mother of parliaments', we had the sudden resignation of Harold Macmillan as prime minister in mid-term, when there had been no consultation with either the electorate or most of his party or the House of Commons – and how a new prime minister, Alec Douglas-Home, an aristocratic member of the House of Lords, had taken office without having stood for any kind of election in his life. I also explained that this unelected prime minister, although having a modest terraced house as his official office and residence, had far more actual power over his government than an elected US president would have had. Later, there was something else to explain: how Douglas-Home had decided to offer some semblance of proper democratic process by becoming 'elected', and that he had done so in a risk-free, manipulative manner by arranging to stand for the next vacant 'safe seat'.

On the urban design course at Penn there was an emphasis on teamwork – an important preparation for later life and the management of complex urban projects. There were also more female students than I had been used to. At Newcastle there had been only one woman on our entire course; at Penn there were many. Until then, I had concentrated on developing an artistic side to my work, but at Penn I gained intellectual confidence through friendships, coursework, reading, team debates and intense lecture courses.

As far as I was concerned, not only the spirit but also the language of Postmodernism took root in Philadelphia in the 1960s. In 1963 there was a major

exhibition of US Pop Art at the Philadelphia University art gallery. The emphasis on accessible content, communication and language over pure form made a big impact on me; posters, packaging design and beautiful images from comic books had been the everyday art world of my childhood. I also revelled in being near the centre of the modern art world – New York having largely taken over from Paris in the second half of the 20th century. I went to galleries there (it was only a short train ride from Philadelphia) to exhibitions of modern artists such as Andy Warhol, Roy Lichtenstein, Claes Oldenburg and Jackson Pollock with an enthusiasm I had never found before.

Apart from the influence of painting, my exposure to ecological concerns made me realise that there was another, postmodern way to look at life – an alternative to the utopia of ideological social engineering and the mechanistic pseudo-scientific view of international architecture. I began to see a world where design was closer to the humanism of Bob Venturi, where everyday life was the primary component, and to understand the concerns of ecologists and sociologists such as McHarg and Davidoff. This not only consolidated my childhood interests in habitats and landscapes, but also gave new meaning to the two books that had particularly influenced me as an undergraduate at Newcastle: *1851 and the Crystal Palace: Being an Account of the Great Exhibition and its Contents of Sir Joseph Paxton and the Erection, the Subsequent History and the Destruction of his Masterpiece* (1937), and D'Arcy Wentworth Thompson's *On Growth and Form* (1917).[9] The former was about technological innovation that grew from enclosing and nurturing nature's abundance in glasshouses. The latter drew on inherent structures in nature that gave inspirational clues to the efforts of designers to understand the origins of their form-making.

As various influences converged and coalesced, my passions were moving forward apace. As I expanded my horizons, many more things connected with one another and made sense. The culmination of this period was an intensely personal thematic exploration of organic shapes and forms – many of them collages, repeated and reshaped from coloured pages of books and magazines. I called them my 'organics', and I still have some of them today. They were a kind of release, a therapy – eye and hand together synthesising some of the multitude of ideas that I was now taking in. (Figure 4.4)

And so I used the two years in America to absorb, watch and expand emotionally and intellectually rather than compete as part of the system. I've no idea what place I came in the class as it wasn't relevant to me, which probably indicated that I had achieved a level of extreme confidence and self-assuredness. I watched, learned and travelled throughout these two years, a keen observer, and tucked it all away as part of my learning and life experiences. But the most valuable experience I acquired was to come to terms with and adjust to what I had achieved and how far I had come – it was a time of consolidation and freedom from the pressures that I had put myself under in the undergraduate years. Denise Scott Brown commented when discussing my final reference from the university that I was still very mixed up; she should have seen me ten years previously!

I had saved money from the generous Harkness Fellowship and had got two RIBA prizes to finance travel – the Rose Shipman Award and the Hunt Bursary to study public housing in Japan. The architect Fumihiko Maki helped me find accommodation

in Japan and showed me around the new Olympic buildings. Then I went to Hong Kong, which I particularly fell in love with; I've been going back ever since, and Farrells now have an office there. At that time the primary reason for my visit was to see an old classmate of mine from university, Cecil Chao, whose daughter, Gigi, would one day work for us in London and Hong Kong. I loved the sense of purpose and the 'can do' attitude which was so palpable in what the Hong Kong Chinese were doing. I kept going back every few years, and it seemed to be a city that was obsessed with change.

* * *

London had apparently revolutionised itself and its social order in my absence. So far in my life I'd felt I was going on a walk in the mountains where I couldn't see the future I was heading for, but at last I began to glimpse my goal. The first thing I realised when I returned was that swinging London now accepted and encouraged working-class types much more readily; they appeared to be thriving. But I didn't assume that I'd overcome the inherent problems of the profession I had entered – the Architectural Association was predominant and essentially private in terms of fees. Through Nick Grimshaw I got a teaching position there and I ran a course as a unit master, as soon as I flew back from my travels. I was now on equal terms but I realised very quickly that there was much work to be done in this very hierarchical profession that I had somewhat naively entered. Perhaps Father Cassidy had been right to some extent – but it wasn't university or sixth form I wouldn't cope with, rather I wouldn't cope with life as an architect, with its social orders and hierarchies.

My luck changed again and for the better when Nick met me for lunch while I was working for a short while at Colin Buchanan's, near Hyde Park, and he put to me the idea that we could set up in practice together. His uncle George, a missionary, had offered him a project, to convert part of a terrace of 19th-century houses in Bayswater into accommodation for the Anglican International Students Club. He had thought this all through in advance. The practice was to be called Farrell/Grimshaw, and he had drawn up a plan where he would design a new service tower for the building and I would rework the existing building as the student hostel proper. I accepted immediately. I realised this was a big step and an opportunity for independence and having my own practice – but what I didn't realise were some of the implications of what I was undertaking in terms of the different things Nick and I wanted from our partnership. I rented a house in Islington, and secured a bank loan, using Nick's uncle as a reference, so I could sub-let rooms and open an office in the basement. The day I got the £640 loan from the National Westminster Bank agreed, I went on a long walk and I remember sitting on Parliament Hill and thinking 'The world actually works, it bloody well works!' I had found that I could see the top of the mountain now and it seemed within reach – I had been merely traversing the foothills up to that point.

Farrell/Grimshaw took on very different work from that of many of our contemporaries, for whom this was an era of new towns, public housing estates and greenfield universities – all Welfare State projects. We made our living for about ten years from what would today be described as private urban regeneration, which included converting houses and eventually whole streets into flats and mixed uses.

The students' hostel in Bayswater was very much part of this pattern. The aim was to marry the Church of England's missionary commitment to helping African and other Commonwealth students to the building of low-cost accommodation in London. The initial phase of the project involved the purchase and restoration of six derelict houses on the corner of Westbourne Terrace and Sussex Gardens. Empty since the Second World War, the houses were full of dry rot, and the project was fraught with difficulty from the beginning. Empty derelict houses in an area where now, 50 or so years later, even the smallest of bedsits sells for hundreds of thousands of pounds, were a legacy of the immediate postwar decline in London's fortunes. The houses confirmed that neglect is the great conserver, since the basic structure and most of their fine interiors had not been modernised and were therefore largely intact. But our approach was not merely conservationist. Like the (albeit unexecuted) giant geodesic dome over part of Manhattan that Buckminster Fuller proposed in 1960, our project was characterised by pragmatic radicalism rather than the ideological utopianism of Le Corbusier or Walter Gropius. The hostel was built as a private-sector development. Many commentators thought the result, on a fine architectural street in the middle of town, preferable to the newbuild greenfield solutions of the state system, and believed that the inherent lack of bureaucracy within the client body had contributed to the successful outcome. By looking at how existing buildings could be reused, we kept the costs down, and completed the hostel for less than half the cost and in half the time that the University Grants Committee usually allowed for student hostels. (Figure 4.5)

Nick's service tower was a very clever and thoughtful piece of work that subsequently attracted much favourable attention. I designed the mobile furniture and interiors for the main building, including the bedrooms, and the furniture for the shared areas was built by Nick's cousin, John Grimshaw (the founder of the sustainable transport organisation Sustrans). The bedrooms were fitted out for a total of £73 each, their central feature being a furniture trolley. The trolley wasn't iconic in the way that the service tower was, but it was similarly consistent with the idea of the building shell being separated from the new service element within. I regarded that trolley as innovatory as well as being an accessible and friendly piece of design. Buckminster Fuller was full of enthusiasm for it, as well as for the service tower, when I showed him around the hostel soon after it was completed. Today, more than 50 years later, there are several reinterpreted versions of the trolley for sale. The idea has at last come of age as a commercially viable lifestyle product. (Figures 4.6 and 4.7)

Alongside my part in the design process for the hostel, I also had to concentrate a considerable amount of time on the conversion of the houses and running the overall contract – dealing with the big picture. To some extent, this set the pattern for the way we worked for the rest of our time at Farrell/Grimshaw. Nick usually took responsibility for the more self-contained and technically interesting aspects of a job. He had identified a role and ambition; his focus was clear to me and to all those around. I realised the opportunity that existed for me, even though it was in a back-up role or on the aspects that offered less potential for fame and recognition. He had the advantage that we had set up together as a result of his uncle's patronage – and it was a dynamic I found hard to shift. It is often said that the first six months of any relationship sets the pattern for its duration; to change people's interactions is often

harder than changing buildings and cities, and I would have to wait a good few years before the disadvantages to me of this interactive imbalance were overcome. There were nevertheless many advantages in the relationship, and I was determined to use the years well, to discover and learn in the widest way I could.

We then began to explore several private housing conversion projects around Bayswater based on our work on the Sussex Gardens terraces. Characterised by large 19th-century stuccoed houses, Bayswater is one of the classic London neighbourhoods built by Victorian property developers such as the Duke of Westminster's master builder, Thomas Cubitt. There are wide boulevards including Westbourne Terrace and fine squares such as Cleveland Square, and the proximity of Hyde Park to the south made it, in spite of its postwar decline, a fine place to live. Many of the terraced houses are built on an impressive scale: from one house alone, on Westbourne Terrace, I quickly and economically created eight ingenious and spacious new flats, exploiting the double-height rooms, basements, light wells, roof voids and galleries, and installing spiral staircases and compact kitchens and bathrooms. Over the next five years I created over 300 new homes in the area. After the Second World War, the lack of servants to work in large houses fuelled a demand from a new generation of Londoners for smaller dwellings, which in turn brought about a vital shift in mortgage lending regulations. Mortgages had been available for a long time for houses, then eventually for purpose-built flats, but not until the 1960s were they normally available for apartments converted from existing older buildings. We thus immersed ourselves in the private sector, and I led on all of this. It was architecture as earning one's keep – concentrating on getting clients, not waiting for patronage, whether haute couture or the Welfare State, which both depended on the 'old boy network'.

* * *

The mid- to late 1960s were a time of considerable social mobility, and I watched the success of David Bailey, Twiggy, Don McCullin, the Rolling Stones and, from the North, The Beatles, The Animals, David Hockney and so on. They were all involved in performance, music and art of an immediately responsive nature – photos were published instantly, and the record industry was ever searching for working-class talent. Compared with other creative industries like the media, art and advertising, the architectural scene was much more socially immobile and this was something that I hadn't realised at all at the outset. This situation was particularly obvious to me at a drinks party I attended at Nick's flat in the early 1960s. I remember it well: I met Chris Chataway and was fairly blown away that one of my athletic heroes was casually mixing with Nick, his sister and their friends. Then I reflected much later on that Roger Bannister, Chris Brasher and Chataway were all Oxford people – Brasher and Chataway were Bannister's pacemakers when he ran the first sub-four-minute mile at Oxford – so they were all middle- and upper-middle-class, privately educated people who would go on to be MPs, business professionals and leading surgeons.

The resistance within the establishment to social mobility is epitomised by the criticism as late as 1987 of the then Deputy Prime Minister Michael Heseltine – which his fellow Conservative MP Alan Clark attributes to the former Chief Whip, Michael

Jopling – that all Heseltine's furniture had been 'bought', and by implication not inherited.[10] Still at that stage there was a sense that those who aspired to upward mobility were likely to be chancers or wheeler-dealers – like 'Del Boy' in the 1980s BBC sitcom *Only Fools and Horses*, with his catchphrase 'This time next year we'll be millionaires.' In those early years of my career, I had to deal with the stress of continuously reappraising my origins and even my marriage and my Catholicism. My marriage began to crumble – I questioned everything – and Rosemarie and I drifted apart and ended up separating in 1968.

My main beef with Catholicism was the way it intruded into one's intimate life. The depraved behaviour of some Catholic priests, which has been brought out into the open in recent years, was caused it seemed to me by the combination of the priests' enforced chastity and the absolute control they wielded. I remember confession as a teenager where I described being with a girl and was convinced that the priest was taking a voyeuristic interest and indeed pleasure in my experiences. I remember our so-called sex education at St Cuthbert's, led by Father Cassidy. He described to a class of hormonal teenage boys how when you danced with a girl you must keep a respectful distance, i.e. no body contact – room for the Holy Ghost! He went on to say that if you caused the girl (whom he referred to as a 'piece of fluff' throughout) to expose her knees, and you looked with intent, it could be classed a venial sin (according to Catholic belief a venial sin is a lesser sin that does not result in a complete separation from God and eternal damnation in Hell as an unrepented mortal sin would); but if you caused her to expose her underwear while dancing energetically, and looked with intent at it or caused others to do so, that could be mortal sin! He then proceeded to give us a view of Hell and what it would be like to be eternally damned. This continued into my married life, as Catholicism intruded into my intimate relations with my wife. So much so that I questioned everything personal, including my marriage – with the foundations for this breakdown having been laid, as I saw it, much earlier.

* * *

In the meantime the practice of Farrell/Grimshaw saw its own changes. By 1968 the government had established the Housing Corporation to promote the concept of co-ownership housing societies, whereby groups of individuals could club together and take out 100% mortgages. From the contacts we had made in the private field, we assembled a group of estate agents, surveyors, engineers, designers, teachers and others to form the Mercury Housing Society under the chairmanship of the lawyer John Scott. I became enthusiastically involved in the whole business of how the group found a site, secured a 40-year mortgage, built the building, and set about running and managing it. I tried various theoretical experiments such as allowing each member to choose and tailor-make his piece of the building, but in the final scheme the need to keep costs down drove us to make a simple repetitive plan. The challenge of how to maintain choice while enjoying the benefits of mass production has always interested me. In the end, as people's circumstances changed during construction (due to marriage, children and relocation), it became clear that the real answer lay in

maximising flexibility. As a result, the driving force behind our architectural ideas at that time became flexibility more than individual expression and choice.

The focus on flexibility and low-cost, utilitarian, mass-produced building methods, including a lightweight industrial outside wall, led us to a simple plan for this, our second-largest project but our first new building. A building that was designed in plan and construction methods like an office block or factory turned out to have all the innate flexibility that we were looking for. The relationship between converting existing buildings, whatever their complexity, into homes or schools of architecture, for example, and building anew for later adaptation and conversion was not lost on us. We felt that the Modernist 'form follows function' mantra had created contorted and fixed housing forms in which exaggeration of functional nuances and excessive differentiation between types of room, orientation to the sun and overstatement of site problems all combined to make homes which in fact only marginally fulfilled their purpose. This functional expressionism led to homes that were expensive, inflexible, took a long time to build, and in use were more likely to leak and produce alienating complexities of internal circulation.

Our surveyor, Len Baker, found us a site on Park Road, on the edge of Regent's Park, and I immersed myself in agreeing everything from site purchase and government loan to planning consent and construction budget. With 40 people now on board at the Mercury Housing Society, we bought the land and began planning what would be a ten-storey tower of 40 flats (which in January 2002, 32 years after it was completed, was listed by English Heritage as being of Grade II historical importance). It was not a product of top-down paternalistic government housing, nor was it one of the developers making a profit from others. It was a genuinely collaborative venture that freed us as architects to explore and express the building as we wanted to. The core of the group went on to develop and build many more co-ownership housing projects, and together we helped others to build more than 1,000 co-owned homes. All in all, it was an illuminating spatial, town-planning, construction and property development experience that kept us going financially. Both Nick and I honed our business and entrepreneurial skills – in contrast to the many architects of our generation who had financed the set-up of their practice by part-time teaching and entering competitions or building state-funded projects. Political fashions then changed and the co-ownership scheme for creating new homes was ended by the Labour government nearly ten years later (because it was perceived as potentially encouraging a conflict of interest) – and all the lessons learned, the collective teams' know-how and energetic commitment joined the ever-growing rubbish heap of Britain's postwar, stop–go, short-term, party-politically-motivated housing policies.

I led 125 Park Road up to detailed planning application stage, then Nick developed the cladding and internal detailed planning and building services. It was an extremely cheap building – less than £6.50 per square foot – and the curved corner aluminium cladding and internal finishes were all part of a radical attempt to make basic, utilitarian housing that was also fresh and innovatory compared to the heavy precast concrete estates being built at the time, such as Patrick Hodgkinson's Brunswick Centre in Bloomsbury.

Although Nick and I separately took overall responsibility for different stages

of the Park Road development, there was a great deal of collaboration between us. We invariably worked in the same room, and both of us had a special interest in the outcome because we were both going to live there. Each of us ended up with a penthouse overlooking Regent's Park and the skyline of Westminster, for which the repayments were a mere £25 per week. However, neither of us could afford that sum, so we each let half our apartment to a sub-tenant. My tenant was a former Architectural Association student of mine, John Young, who was by then working for Richard Rogers: during the time that John lived at Park Road, Rogers won the competition to design the Pompidou Centre in Paris.

I was to face the reality of the relationship with Nick during early 1969 when the 125 Park Road drawings were virtually completed and we could see the end of the flow of work. I suppose I was by then preoccupied by going to live alone, separating from my wife and two children and striking out on my own in my private life. But Nick announced one day that the practice had run its course and we had no new work in prospect, and we could then go our separate ways. The establishment of a practice, it appeared, was not something that he was invested in and I had been the unwitting enabler of his solo career as he saw it. We had a crisis meeting and I said, 'Let's give it a year' (which would by then be after we had moved into 125 Park Road, in July 1970), and that if I didn't get new projects then we could dismantle the practice. He agreed, so during that year I got busy and formed with the Park Road professionals a housing society funded by the Housing Corporation and set about expanding the practice. Our efforts proved successful, setting the course for a steady flow of work for the next five to ten years – and so the Farrell/Grimshaw partnership continued after all.

* * *

By the end of 1969 I had met Sue, who was to become my second wife. Her family came from Essex, her father was a bricklayer and, as Nick said at that time, 'her father was a nobody'. I recognised then what I know now: that we had adjusted to our social expectations. I was settling down to where I felt comfortable, and this was the beginning of a long period of reappraisal for myself and Nick. The parties were over, and the Swinging Sixties were over – not just for us, but for everyone.

The 1970s

The 1970s were a time of re-evaluation of the shifts that had taken place in the 1960s, and consolidation. I was ready and prepared for this re-evaluation, but Nick ploughed on with his stylistic choice, as I think so many successful architects did from our generation – a result, I felt, of the Architectural Association's branding process. With the success of Park Road and with Nick and me moving into adjacent penthouses there, we were seen outwardly as a successful partnership, but privately the imbalances and frustrations were beginning to emerge. He was clear about what he wanted to do – to be the privileged designer in the practice – and I admired him for that clarity. I could have gone along with it and have ended up designing and managing the bread-and-butter projects to keep the practice afloat, but I knew that was doomed to fail because I was a designer too, and it was primarily social circumstances that had cast us in our different roles. I spent the transitional period of the 1970s challenging and undoing these assumptions, and acquiring the remaining skills and mental outlook I needed to cope with the practice. But Nick never varied: he stuck to what he called 'the sheds' – factories, warehouses and the like – and the detailing, in a kind of kit-of-parts approach. To me he was more of an industrial designer; he had trained initially to become an engineer, but he had experience through his friends and family in publicity, and presented to the outside world a carefully manufactured appearance – the 'brand' of the practice. The photographs of Park Road say it all, making us look as though we were an attached-at-the-hip duo, while that wasn't the reality. The 1970s exposed the gaps which, by the end of the decade, would lead to us going our separate ways. (Figure 5.1)

Our differences extended to our life-partner choices; we both got married in the early 1970s. Nick married Lavinia, a well-connected only child who was internationally educated and from a well-known family. I married Sue from Essex, who had had a successful student career at art school. She was a meritocrat like me, and was for another way of seeing: not sticking to the conventions of architecture, but more liberated by pattern, variety and freedom of personal expression, I felt. The differences were further epitomised by the homes we created after we left Park Road. Nick went to live in a stuccoed Victorian house in Primrose Hill, while we chose a 1920s semi-detached house in a suburban development (but more central, in Maida Vale) and proceeded to indulge in the stylistic/spatial opportunities it offered. It was partly a case of restoring the house that we'd bought, working with its attributes, but at the same time exploring popular taste and culture, and this continued and evolved throughout the 1980s and 1990s.

* * *

Having undertaken to find new work, I took my future into my own hands to survive and prevail. The obvious decision, I felt, was to capitalise on the housing society we had set up to found and build the Park Road flats. So in 1969 I and my fellow professionals from Park Road set up the Maunsel Housing Society, which was to be a major source of work and expansion, directly or indirectly supporting the practice for the best part of the 1970s. Over the next ten years it built over 1,000 homes by bidding for sites on the open market and then developing them with the combined team's expertise.

My first act was to bid for a large site in Wimbledon, which we didn't win. But I found out who did win it and arranged to meet them, to show them my scheme. And so I met with Samuel Properties, who agreed that Maunsel had a good scheme and could take the rear of the site for flats along the lines we had designed, leaving the remainder as houses for sale with other architects appointed by the developer; I suppose it mirrored today's private/social housing split on sites.

This led to unexpected consequences, one of which was the largest scheme we built in the 1970s – a complex of 250 flats with offices, shopping and the design of a public library. Unknown to me at that time, Samuel Properties were assembling land for Westminster City Council for its new civic centre, which after the creation of the GLC and the establishment of the new boroughs was land no longer required. Westminster Council subsequently decided to sell the site, with developers taking the private housing and commercial space and in return providing the council with a free library and social housing. Samuel Properties were not on the approved developers list, having been excluded as they were not recognised as having sufficient quality of developments. Unknown to us they won over Westminster Council on the basis that they would use Farrell/Grimshaw as proof of their quality aspirations, having just met us on the Wimbledon project. I received a phone call from Samuel Properties summoning me to discuss the opportunity that had arisen, as we were shortlisted. I designed a solution which respected the urban grain that historically existed,

primarily by conserving the spatial framework of the Victorian site – the back gardens as landscaping and the mews house form in the centre of the site. Having spent five years converting houses in the area into flats for private sale, I confidently proposed at the competition stage (ours was the only scheme to do so) that the two-thirds of Porchester Square terrace that came within the site should be fully retained and made into flats, and that an existing arched opening in the terrace that had once formed the entrance to a mews should be preserved. The next step was to recreate a former street pattern, including the mews, and carry it to its logical conclusion by building the remaining accommodation along the street frontages with ground-floor front doors all around the block. My design also kept the development low-rise while achieving the maximum density the developers required to make the scheme viable. Our chosen scheme was featured in the *Evening Standard* at the time with the headline 'Packing Them In Without The Towers' (19 March 1972).

The entire scheme, eventually called the Colonnades, was first and foremost a piece of urban design, and as such made an interesting contrast with the adjacent Tecton scheme of 20 years earlier on the opposite side of Bishops Bridge Road. I had met with the scheme's job architects and they explained that Tecton's public housing was deliberately non-contextual, comprising angled slab blocks that sit back from the surrounding 19th-century terraced streets. Finely designed in themselves, the blocks represent a classic Modernist layout that is disconnected from its site, as it's surrounded by a railed enclosure; the buildings stand in a separate world. As much a place of ideas, even ideology, as it is a 'home', the Tecton scheme was led by the maxim that 'light and air' should be the architect's first priority. In the same way that Postmodernism ended up as a reactionary movement, Modernism relied to a degree on selective perception – giving too much emphasis to the importance of daylight and the 'overcrowding' of earlier Victorian terraces to make its case. For there to be harmonious urban and architectural continuity, the perceived sins of the fathers needed to be reviewed in a more balanced light. The intolerant narrow certainty of Modernism was a reaction against Victorian omnidirectional excess. Postmodernism, an era of greater tolerance and pluralism, had its own inbuilt problems but marked the start of a period in which greater fairness and balance were brought to bear on the process of assimilating the work of earlier times.

There is still a demand even today for architecture to be 'innovatory' in the sense that a scientific breakthrough or technological invention is innovatory. I have always argued that it is equally innovatory, or even more so, to go against the grain of fashion and reinstate neglected traditional ideas when they are still alive and appropriate. Interpreted in a broader, non-scientific sense, innovation can be social, artistic and even moral. The trend at that time for demolishing fine buildings and eliminating good streets and neighbourhoods in the name of progress needed to be energetically challenged. Demolition was often in one's self-interest, serving only to bolster the egos of ideologically fixed architects and various ambitious politicians. The message of Jane Jacobs's book *The Death and Life of Great American Cities* (1961) had been embedded in me since my student days at Penn, but Jacobs's views were not yet widely known in the UK. A great deal more demolition would take place and many more

inappropriate urban projects would be completed before the real innovation of a creative architecture that included conservation and adaptation of existing buildings was recognised for what it was.

If the collage of old and new (buildings and street patterns) in the urban design plan form of the Colonnades was an innovation, so was the horizontal layering of the mixed-use newbuild with rooftop patio housing and offices, shops and pedestrian arcades, and all of these above an underground car park that set the entire spatial framework and structural grid. Mixed use is a shift away from the sanitised 'zoning' of Modernist planning and always makes for complex, less clean and less so-called 'rational' architecture. Two pieces of architectural endeavour particularly engrossed me at the Colonnades: the rooftop patio houses above the long-span shopping area on the ground and first floors, and the tight juxtaposition of old and new in the design of the retained terrace of ten houses, which created a challenging complex section incorporating a great variety of house types. Urban design engages a wider spectrum of political and community interests than architecture does, and for me the Colonnades was a first foray into a public/private partnership – although, to my regret, the library was never built.

* * *

In the years that followed, it became clear that the evolution of the Colonnades reflected a malaise that persisted in Britain from the 1950s to the 1970s. The malaise was characterised by deliberate destruction of place and identity for political reasons; it was not just physical, and it was not just about streets and buildings. When it comes to valuing the heritage of a place, I have observed that there are some surprising and unexpected differences between the USA and the UK. While American districts, cities and states and the organisation of their governance have remained unchanged in most respects, Britain has gone from tinkering to downright abandonment of many worthwhile traditions that make up our society's collective identity, while keeping the underlying class structure with its intrinsic protected hierarchies intact. Our long-established counties have been diced up, scrambled and renamed in the interest of redefining purely political bureaucracies and conveniences. Ancient counties such as Cumberland, Westmorland and Rutland were eliminated. The county of Huntingdonshire was abandoned and then, confusingly and half-heartedly, partially reinvented later in response to public protest. Cumberland and Westmorland became Cumbria; and whole new districts arose with misleading name-making like Avon and Cleveland. Sale, the small town where I was born, 'moved' from Cheshire to Manchester and then to Greater Manchester. The result is that many people are confused about county boundaries and their relevance. Knowledge of where we are is a fundamental part of knowing who we are. The culprit is a kind of radical modernisation that makes the past responsible for all our ills, just as children can, if they choose, blame everything on their parents. The changes to the national and regional map of England in the last 30 years were made regardless of meaning or understanding – they were superficial changes, rather than dealing with the genuine issues that were confronting our society.

I am fascinated by how the USA, the most pragmatic and dynamic of nations, has kept many meaningful collective-identity traditions, in various domains, while we in Britain have not. One such is the boundaries and geographical outline of the individual states, which never change; the other domain is money. I refer not to the pound/euro debate but to the continuous redesign and total reinvention over the years of the shape, colour and graphics of all our coins and banknotes in the UK. In contrast with the British currency, the dollar bills that were in existence during my trip to the USA in 1962 are still recognisable and still fully workable today. What does money recognition stand for if not a commonly understood language of value? The shape and form of life's currencies – political, territorial and financial – create our sense of place in the world. Collectively perceived continuity and identity have to be part of the discourse when debating any change; if they are not, few of our plans will achieve much more than merely superficial change.

* * *

Any urban-design-based project is a marathon rather than a sprint. The Colonnades took seven years of my professional life; later on, the Comyn Ching Triangle in London's Covent Garden would take 15 years, and projects of large urban complexity such as Newcastle's Quayside and Edinburgh's Exchange are still evolving after many decades. (Figures 5.2 and 5.3)

The work on the Colonnades commission was an extreme contrast with High-Tech work on factories and warehouses that was being done in parallel by Farrell/Grimshaw. The latter projects often took not much more than a year from design to completion, and sometimes even less. Led now by Nick, we had built several of these by the mid-1970s, including Rotork Controls, Bath; Editions Van de Velde, Tours, France; Excel Bowl, Reading; and the Citroën Warehouse, Runnymede. All were non-urban explorations of high-tech, lightweight system building that implemented some of the ideas that had excited us in the late 1960s. I was particularly fascinated by the work of architect Ezra Ehrenkrantz and the more abstract concepts of his flexible school systems. The influence of this would feed several years later into urban factories at Wood Green, expressive High-Tech at Clifton Nurseries and the facilities building for Thames Water Authority at Fobney near Reading. (Figure 5.4)

For the first time we were beginning to receive the recognition we needed to continue our practice, including a special issue on our work in *Architectural Design*.[11] However, survival was still uppermost in my thoughts. Today when architects leave us to set up on their own, I say to them that it is not the first job that matters, it's how you follow it through. While you are busy working on those first jobs, how do you set time aside to think about the next ones? How do you pay for them and how do you staff them? The end of the first five years is the toughest time, as it had been for us. (It pays, of course, to have money at the outset and not have to earn your keep from architecting!)

Our bringing together of reuse and newbuild – the subject of an essay Nick and I wrote for the *RIBA Journal* in October 1974 entitled 'Survival by Design'[12] – was as innovatory as any other practice's approach at that time. But we did not have the iconic

landmark projects of our former rivals. Norman Foster was doing the Willis Faber & Dumas building in Ipswich and the Sainsbury Centre in Norwich, and Richard Rogers was building the Pompidou Centre in Paris with Renzo Piano and Peter Rice of Ove Arup. We had outgrown our Windmill Street office and in 1972 had moved to Paddington Street, where we fitted out the studio with furniture from the Herman Miller Action Office 1 series. The interior was open-plan with flexible ribbed tubing and hanging ceiling servicing systems, all in primary colours. Richard Rogers's office was around the corner from us at the Design Research Unit behind Marylebone High Street and we would all meet on occasion and have lunch, compare notes and chat.

* * *

The overriding new factory ethos of Farrell/Grimshaw did not fit in with what I was enthusiastically observing and studying in the urban districts of Marylebone and Paddington, where I lived and worked. As I explored urban design, conservation, variety and individuality more and more in all my projects, a gradual separation was emerging between the two sides of the office. This was an almost imperceptible process, but by 1976 it was clear to us, our staff and clients that Nick and I were on divergent paths (Figure 5.5). Earlier on, the public evidence surfaced in our first big lecture in 1974 at the RIBA, part of a series called 'Architects' Approach to Architecture'. The lack of harmony between us made it difficult for either of us to organise our slides or to agree on what we wanted to say on the evening – and the lecture was described by commentators as disjointed. But when a year later we were invited by the writer Charles Jencks to give a talk at the Architectural Association, we were able to regroup and rationalise coherently our differences of approach. We followed the AA talk with one at the RIBA, which we published in the *RIBA Journal* under the title 'Buildings as a Resource'.[13] The essence of our thesis was that all buildings change and evolve, and whether you are working on new buildings or converting existing ones, the same issues emerge. I championed that ours was an integrated view that took the doctrinaire rigidity of much Modernist thinking and treated all buildings as part of a linked pattern of design strategies, but we came at the thesis from quite different entry positions. The challenge for me personally, as I saw it at that time, was to find a way to present our differences as part of one unified approach. Contained in this essay were, for me, all the elements of a Postmodern perspective as it grew out of the contradictions and challenges of Modernism.

I therefore began to seek to humanise mass production by creating places and homes that were more capable of individual expression. This was quite different from elevating the universal industrial product as an aesthetic icon. Since encountering the childhood frustrations of broken bicycle chains and various tyre punctures, I had had mixed feelings about loving technology as an end in itself, even though I saw that, for my elder brother (who liked his Meccano sets), repeatedly taking a bike to bits and rebuilding it was central to his pleasure in the hobby. Not for me the endless joys of the machine for its own sake. At Park Road I had become interested in marrying the factory-made with personal choice, although many people around me

had difficulties with this idea. Later on, in the housing society projects, I had focused more on combining individuality and uniqueness of place with mass production. As the excitement of the 1960s faded, a new and more responsible mood began to prevail, caught at Charles Jencks's seminar at the RIBA Hull Conference in 1973, I recall, when the architect John Darbourne remarked that 'there is nothing that gets the water off the roof better than tilting it'. There was applause and much laughter. The use of the 'flat roof', that essential icon of Modernism, could no longer be a guaranteed badge of office for the dedicated contemporary architect.

Maunsel provided some absorbing work and we enjoyed it while it lasted (as I mentioned earlier), until the new Labour government decided in 1976–7 that the arrangement might promote professional self-interest over and above the potential public housing gain, and so Maunsel was absorbed into other larger housing organisations.

Architecturally, the organisational process we invented for construction for Maunsel was as important as the finished product and generated a different kind of building. In essence, we persuaded the government agencies to accept one timber-frame contractor for a large number of projects, who then produced the building shell at a predetermined price – it was called a serial contract. The shell would vary from two to four storeys but was always constructed from the same grid and standard panels. Then, quite separately, for each of the infill sites around London, a local contractor was selected to build the foundations and drainage and then to return and complete the cladding and landscaping once the timber frame had been erected. All this therefore combined the involvement of local, small-scale builders with larger contractors' repetitive core construction. I was determined to combine mass production and the benefits of scale with individuality and placemaking. Some sites had timber-clad houses, others near the airport used brick for sound insulation; some houses were hung with tiles, others combined tiles and timber. (Figure 5.6)

In my concern for buildings as a resource and as part of my involvement in developing strategies for public housing that challenged current wisdom, I undertook a study for Westminster City Council of several of its very large estates – which, by then, contained a total of more than 1,000 homes often over 50 years old. The study looked at how, instead of being demolished, these homes could, through adaptation and improved services, be replanned and reused to prolong their life by another 60 years. *Defensible Space*, Oscar Newman's book of 1972, gave me some excellent clues about how to create safer public realm through imaginative and thoughtful urban design and management.[14] The 1,000 dwellings report became a mini-manifesto in which I argued passionately that those proud, well-built housing estates consisted of handsome buildings that we, in the late 20th century, rarely equalled. Yet everywhere I was hearing that the case for their demolition was self-evident. The medium-rise traditional-style brick flats that were purpose-built by the London County Council are among the best housing achievements in London, with their traditional construction, adherence to street frontages and their modest 'not trying too hard' architecture.

* * *

We at Farrell/Grimshaw were successful and expanded from a handful of people to just over 30 – we were a proper organisation. I loved the fulfilment of having new projects for several sites all over London. I discovered I was very good at winning and organising projects. This business of architecture was much more complicated and complex than I had ever thought possible, but by the mid-1970s I had mastered so much of it. However, the workload was becoming imbalanced between Nick and me. He had one or two boutique factory projects that he had found through friends and family connections; I was building complexes that needed big teams.

The workload situation was the cause of our first major confrontation. Because he had less than half a dozen employees and I had 30 to organise, I argued that it was the staff that revealed the workload. He argued that he was the originator of the style, image and brand of the practice. But I was beginning not to identify with the brand; I was beginning to think about a wider architectural taste and also about urban design. My interests led me towards looking at popular taste, which was about as far away from the High-Tech aesthetic as I could get. This goes back to my time at Penn, and Davidoff and McHarg's profound influence on me: whereas I had been one of the initiators of High-Tech in the very early 1960s, I was confident enough to then question it while not denying my roots in it. Somehow, though, we balanced up the workload, and we continued right up until the political machinations that resulted from the worldwide oil crisis in 1973–4.

The oil crisis is a complex, separate story, but one of the impacts it had on us was due to the Three-Day Week: a measure introduced by the government, in the face of the coal miners' strikes, that limited commercial concerns to only three consecutive days' energy use per week. I sought financial security, which was very important to me because of my background; a level playing field of not having money worries would mean that I could be in charge and in control. We had invested our profits from the Colonnades and other successful work projects in a property venture. But as it happened this all unravelled; the banks foreclosed due to the Three-Day Week and we lost all our investment. I was capitalising, I had hoped, on my experience of conversions, but it only revealed how much I yearned for financial security as one of the elements that I had not started off with – and that I was to realise, more and more, one needed to compete. (Figure 5.7)

Subsequently, in the mid-1970s recession I was in a state of depression about what life held for me and where I would go. We had established our reputations, but we were still financially shaky and had shrunk from 45 staff at the practice's peak, to just seven: two partners, two associates (John Chatwin and Brian Taggart), two assistants and our secretary, Maggie Jones. I had a business partner whose career was taking off in a direction that I was increasingly questioning. I was relegated to the organiser/manager/provider for that, while developing and thinking about an architecture that was different. And what's more, financial security was an illusion; it was as if I couldn't provide for myself the freedoms and confidence of leadership that came naturally to those who were more secure, more privileged. I found that my interest in refurbishment and conversions, place and popular architecture, which were my roots, was at odds with the practice's 'brand'.

* * *

When I go back and trace the origins of my love of restoring and refurbishment, the trail always leads to the original student hostel, which was for a large number of students and staff with full leisure and dining facilities, converted from six (now listed) stuccoed properties in Bayswater. I had gone on to fuel the income of the practice in the late 1960s with many house conversions into flats in the surrounding area. But I believed in it, there was virtue and value in it all, and this was, I believe, the essential differentiator in us being the winning entry for Porchester Square (the Colonnades). It afforded us (unsung at the time) a reputation for conversion work, later leading to the TV-am building, Limehouse Studios, my own house, offices in Hatton Street and of course the Comyn Ching Triangle.

Interestingly, the Comyn Ching Triangle is in the same neighbourhood as a site that was the subject of a project in Nick's Architectural Association thesis submission in 1965, which I helped him with and even did some of the drawings for. His proposal involved knocking down all of Covent Garden and replacing it with zigzag walkways. My approach ten years later was completely different, reflecting my love of conservation and community architecture. Comyn Ching and the other large-scale urban-design architectural projects that I took on afterwards, such as Byrom Street in Manchester and a scheme for the centre of Aberdeen, all began with issues of context and conservation – in Comyn Ching's case, of some 25 early-18th-century houses – and revelled in the mixed use and variety of building types. In retrospect, the Colonnades had not explored thoroughly enough the architectural possibilities of this variety.

The Comyn Ching project fulfilled many more of these ambitions. On the three corners were new buildings, each with a different client as we were determined to stay with the project and complete a full urban block. The first enabling stage was by far the most interesting; it was for the original site owners (the ironmongers, Comyn Ching) and it set the value and therefore the stages that followed. It was an essay in a landscaped courtyard with many listed and diverse buildings surrounding it, in which we exploited colour, pattern and variety for all its worth. We had a 40 year reunion for the team that worked on it when it became Grade II-listed by Historic England in 2018. The team was as diverse as the resultant architecture, as it took nearly 15 years to build out, and was for four different clients.

My philosophy of conservation, conversion and refurbishment being integrated into new work came to a head in response to Charles Jencks taking a real interest in what I did from the mid-1970s onwards. I enjoyed talking and discussing with him theories of architecture and its role in city-making, style and context. His commission of a house for his new wife and family became a key factor in the eventual split between Nick and me. When the chance came up of collaborating with Charles and Maggie Jencks, and of working on their house just off Ladbroke Grove, I acted out of character in that I took the opportunity with both hands and saw this as a personal chance to break from my current path and determine where I stood.

* * *

I found myself beginning to be really concerned about the future of the practice by the late 1970s, due to the collapse of projects with the Three-Day Week and the political and economic recessions that followed. Slowly things turned around, as they always do after a recession, but after that one we emerged more separate than ever. It was in Warrington and Winwick Quays, at the Herman Miller factory in Bath and later at Aztec West, that Nick was beginning to gain momentum with what he called 'the sheds', which I've always acknowledged he did extremely well. But I no longer identified with his architecture on its own – it wasn't enough for me.

I became involved at this time in what I considered the thinking man's version of sheds. Wood Green was a gritty, congested, older urban district containing Bassetts – a large confectionery manufacturer – as well as gasometers, warehouses, factories and a car repair shop. As part of its support for blue-collar employment, Labour-controlled Haringey Council had obtained several separate sites, and our developer client, in a public/private partnership with the council, set about creating a new work district with strategic demolitions, conversions and new infill buildings. I was intrigued by the complex ad-hoc-shaped sites and various neighbouring structures, and the fact that there was, as in most urban models, a site coverage by buildings that was well over 50%. So, instead of making 'pristine' (a favourite Farrell/Grimshaw High-Tech word) standalone objects, I began to invent workplace courtyards and linked industrial buildings (possibly influenced by the Danish architect Jørn Oberg Utzon), shaping a neighbourhood united along city streets by a series of solid walls of enclosing brick with, behind them, fully glazed internal courtyards. Instead of the glossy box, the object positive, it was the reverse: the space positive, a series of internal courtyards for deliveries, vehicle manoeuvring, and arrivals and departures. It was these central spaces within a dense, mixed-use urban grain that were the essence of the scheme. Wrapped around the internal courtyards were High-Tech flexible walls that borrowed from what was going on elsewhere at Farrell/Grimshaw. To temper the mechanical effect of these, I introduced 'solid' and 'void' windows within the curtain wall, exposing some gasket-free glazing bars to suggest windows in the mandatory 10% wall area set aside for insulation – a sacrilegious visual pun, since it was the only part of the wall that was in fact solid (Figure 5.8). I am reminded of Nick's description of a light-hearted mezzanine flooring scheme I had done at that time as 'an immoral use of Dexion'.

I had a good job architect, John Petrarca, on the Wood Green project, and we turned the business of designing what could have been earnest utilitarian sheds into buildings full of personality and expressive of place. Around the outside was brickwork – something that would never have been considered in the early Farrell/Grimshaw High-Tech factories – with geometric patterning and stepped windows. We saw this inside-out architecture as resembling a 'geode': protective and hard outside, rich and sparkling inside. I revelled in a series of architectural surprises. For example the steel prefabricated stairs were not in a macho, mechanical primary colour (which had been de rigueur from Archigram and the Pompidou Centre onwards), but in pink with small inset rings of cut tubes (leftovers from offcuts of the central circular column) forming a decorative pattern around the central steel column. Petrarca (who was from New York) and I compared the concept of mass production in the USA and Britain, centred

on this very detail. At that time, a standardised factory product in the USA was simply that; the size of the country and its huge market created efficiencies and economies of scale that brought prices down but in effect severely limited choice. In 1960s Britain all models of cars were idiosyncratically different, and so-called mass production was a craft industry based on a much smaller market than the USA; products were not aimed at the population at large but designed to satisfy the perceived taste and buying power of the middle class. Petrarca chose a 'standard' stair from a British catalogue, but soon found that no stair was in production and any variation requested was possible. It was a master-and-servant relationship, but with a more aspirational technological aesthetic than any of the mass-produced American products. In this way, the British middle class, including British designers and architects, for decades expressed progression and 'modernity' stylistically but with buildings that were the constructional equivalents of bespoke suits from Savile Row.

The buildings were let very quickly – the last one to Middlesex University's Art Department, for which we designed and created a sculpture and painting department (with industrial elements forming 'Ionic' capitals) in an industrial courtyard unit near Wood Green town centre. The university arts building has since grown in influence to such an extent that a lot of the area had become an arts quarter by the end of the 20th century. I went back to photograph the buildings and found that almost all of them had been delightfully overgrown with ivy.

* * *

Before Nick and I went our separate ways, we began the design of the water treatment works near Reading for the Thames Water Authority (finished two years later in my own name). The location was geographically fixed by the river at Fobney and the existing sewage-treatment works. Operators of public industries were beginning to think about communicating their role in people's lives and explaining what their workplaces were all about, so the brief included a visitor centre and exhibition area. The Thames Water building once again eschewed architecture as product design, and we intensified and elevated the specialised and functionally complex brief rather than reducing it to oversimplified components. A long, low building had been deliberately placed above the water treatment basements; its purpose was to prevent lift caused by the high water-table pressure associated with nearby rivers. We worked to transform what could have been an undignified building by engaging with the potential to employ symbolism and visual metaphors. The cladding was the pale blue of clear water, with shiny reflective glass bubbles rising up the facade; some black gaskets were removed to reveal the bright blue edging of the enamel paintwork. A giant wave surmounted the roofline silhouette, and cascading waves of mirror glass created the impression of rollers big enough for surfing. As a knowing aside, the connecting gasket from wave to wall had to be bigger than anything readily available in the construction industry, so it was made from the ultimate jumbo watery gasket – that is, a standard plastic rainwater pipe split down the centre and bent open into shape. Inside, the elements of earth, fire and water dominated in symbolic form the entrance hall and visitor centre – with bright blue foam seating resembling waves, earth-red bridge and

stairs, and five torchère light fittings on columns at the end of the big transverse axis. Although it ventured into new symbolic and visual territory, it was grounded in the technology, materials and know-how of Farrell/Grimshaw, reconnecting me with the excitement of discovery associated with the partnership's early days. Perhaps more importantly, at last I was regaining my contact with the freer artistic creativity of my childhood and student days, which had been characterised by art, colour and joyful, independent creativity.

* * *

The first inkling of the final separation was that Nick told me his wife, Lavinia, was a close friend of Jencks's ex-wife – it was social, it was about connections. With the Jenckses, I was entering territory that had been 'forbidden' to me hereto, for now I was growing into a new social sphere, and sure enough in the last years of the decade they introduced me to Jacob Rothschild, who wanted greenhouses and shops built at Clifton Nurseries sites in Bayswater and Covent Garden. I had moved on to have 'patrons' of my own.

In the November of 1978, on Bonfire Night – a night which had coincidentally featured strongly in my childhood – there was a final confrontation between Sue and me and Nick and Lavinia at a party. The issue of our wives and personal lives had emphasised the differences between us. On the Monday after the event, Nick said that he had decided to end the practice. I resisted initially because I didn't feel ready, and I could tell he wasn't ready either. But eventually it dawned on me that this was an opportunity; it was what I had been preparing for all my life. One night at home in Ashworth Road, Maida Vale, at the end of 1979, I got up early and faced the prospect of independence. I was 41. It was a moment of intense realisation; my future was clear. I decided I was ready.

Figure 1.1 Gorton Friary, once called Manchester's Taj Mahal, is today a popular venue for weddings and conferences after extensive refurbishment.

It is no longer at the centre of a dense working-class neighbourhood as seen in this photo.

> C.S.M. J Murphy
> No 1 Company
> 1st Manchester Regt
> Indian E. Force "D"
> C/o India Office
> London
>
> 12/3/16
>
> Dear Mrs. Maguire.
>
> It is with the deepest regrets that I have to inform you of the death of your husband Sergt Maguire who was Killed in Action on the 8th of March 1916.
>
> It might be of interest for you to know that the Regiment suffered severly in Casualties in the Great Fight. Poor Jim he was my Schoolmate as we went to the Monastery together and I may say that he was one of the Bravest men in the Regt. he as been recommended for his bravery, a happier and jollier man you would never find in a days march as he was always Singing but the last two or three weeks he had been downhearted through having not received any letters from you since we had left France he was very well respected both my Officers + men alike Believe me to remain yours Sincerly J Murphy C.S.M.

Figure 1.2 & 1.3 Letter dated 12 March 1916 to Jim's wife, Mary, from Company Sergeant Major Murphy informing her that Jim had been killed in action.

He mentions having attended the Monastery school at Gorton with Jim and assures her that Jim was brave and well liked.

Figure 1.4

A formal portrait of Jim Maguire taken after his time in the Boer War.

His South Africa medal and associated clasps can clearly be seen. The two stripes on his arm denote his rank of corporal.

Figure 1.5

Figure 1.6

Figure 1.5–1.8

This is the first letter from Jim to his wife after being captured and made prisoner of war after Kut.

His wife had already been informed that he had died in action by Captain Murphy. The letter is dated 26 March (which was 18 days after he was shot and injured). The handwriting is surprisingly good, as Jim explains in his letter that he has had to write it with his left hand due to his right one being injured. He is being treated at the military hospital in Baghdad and being looked after by French nuns. Jim makes it clear that these nuns provided some much needed succour.

also a slight wounds on my Right Arm it was impossible to get back and so I was taken prisoner of War that night. The next day we were sent to a Turkish Hospital and stayed there 14 Days then we were removed on to another one from there we came here to a proper Hospital for wounded. Its not quite so bad it is a little bit strange until we get used to it The Doctor is very nice & we have some French Sisters of Mercy looking after us and my word they are just like Angels

Figure 1.7

of Heaven I mention them in my prayers night & morning and I hope you will do the same
Dear Wife I find it very difficult with only one eye to Business If you write back do not say anything about the and don't send any parcels I will have to close now its just going dark With True Love & Affection & Kisses from your ever loving Husband. Jim
xxxxxxxxxxxxxxx
xxxxxxx x x x xxx

Figure 1.8

Figure 1.9

My grandfather on the beach at New Brighton with me, probably around 1939.

My pram is in the background and there are already early signs of our close bond, and my determined building constructor's pose.

Figure 2.1

My father helped us put up makeshift tents in the garden.

This was taken with my brothers before I started school, and I was around five years old (I am on the far left).

Figure 2.2

In 1946 my parents sold their house at 17 Langdale Road, Sale, and moved to Newcastle.

With some of the sale money they bought a Ford 8 car. This photograph shows my parents, three brothers and me (in order of birth, I am second from the left) outside our grandparents' house in Levenshulme, Manchester, around 1950.

Figure 2.3

Photograph of the sixth form at St Cuthbert's taken in June 1954.
I am in the middle row, fourth from the left.

Figure 3.1

My painting of the Northumberland countryside, painted when I was about 15.
My original love was art and painting.

Figure 3.2

My drawing of All Saints Church in Newcastle, which won the RIBA award when I was 16.

Figure 3.3

My art teacher at St Cuthbert's, Maurice McPartlan.

This photograph was taken during his time at the Slade art school.

Figure 3.4

Memento from the visit led by my father to the Festival of Britain with my older brother in 1951.

Figure 3.5

A page from my Lytham study dissertation.

My student research into the evolution of the deliberately planned Lancashire town, which I did in my fifth year, 1961.

Figure 3.6

My final-year design thesis, 1961, The Climatron.

Influenced by the teachings of Buckminster Fuller, the scheme was a high-tech enclosed holiday island connected to the base of Blackpool Tower. It may have been an early indication of my interest in town-planning and public realm alongside architecture.

Figure 3.7

My first wife Rosemarie and I shortly before we set off for Scandinavia in our BMW Isetta bubble car.

Figure 4.1

The curved form of Blackwall ventilation towers was inspired by Oscar Niemeyer's work at Brasília.
In 2000 the towers were listed Grade II historical interest.

Figure 4.2

Louis Kahn with a studio class at Penn during my time there, 1962–4.

Figure 4.3

Vanna House, Philadelphia, by Robert Venturi, 1964.

Taken when I visited in 1963 – Denise Scott Brown is on the left, and Bob Venturi is in the doorway.

Figure 4.4

My organics student paintings 1962–4.

My way of exploring the visual world, which helped me balance the intellectual and academic stimulus at Penn University.

Figure 4.5

The international students' hostel after construction.
Showing the addition of a top floor and a new service tower containing the bathrooms.

Figure 4.6

The components of the student furniture trolley included a bed beneath made from a flush door – with a unit cost of around £73.

Figure 4.7

1998 drawing – a reinterpretation, 40 years later, of the student's all-in-one unit.

Figure 5.1

With Nick in front of the Park Road flats, 1970.

Not only was this my first new building design, but I lived there from 1970–3 and we, the group that built it, went on to build a further 1,000 dwellings later that decade.

Figure 5.2

Comyn Ching was a conservation-led regeneration of an island site that included 37 18th-century buildings.

The door casements were each specifically designed to allow for a slanted pavement.

Figure 5.3

Comyn Ching, London. This project took over ten years to complete.

The completed courtyard shows retained and new buildings in harmony around 1986–7.

Figure 5.4

Thames Water Treatment Centre, Reading, 1979–82.
Completed building looking towards the entrance.

BUILDINGS AS A RESOURCE

A time of severe recession is a good time to take stock of resources. Our existing buildings should be regarded as a valuable resource to be more fully used. We should design our new buildings so that they add to this resource.

This article expands on a recent lecture by Terence Farrell and Nick Grimshaw of the Farrell Grimshaw Partnership given at the Architectural Association.

TERENCE FARRELL:
CONVERSION AND
REHABILITATION OF HOUSING

Now is the time to ask if we actually need any new housing in this country. Buildings are a resource which should not be destroyed, even if they are to be replaced by a 'masterpiece'. It requires as much design ingenuity to spatially re-organise existing buildings, adding services and equipment, as it does to design new buildings.

NICK GRIMSHAW:
FLEXIBILITY IN
INDUSTRIAL BUILDINGS

Today's enclosures must allow for the ebb and flow of new products and processes. They must also encourage a high level of user manipulation of the interior and exterior of the building. We are against custom-built monuments.

Figure 5.5

This article published in the *RIBA Journal* in May 1976 was a landmark for Nick and me, as it was the first to define how we differed in our approach to architecture and I suppose it heralded the end of our partnership.

Figure 5.6

From 1974–81 Farrell/Grimshaw worked on low-cost timber housing projects.

This shows the Luton flats, which consisted of two floors of flats above ground- and first-floor maisonettes.

Figure 5.7

Cutaway exploded drawing of the plan layers of the Colonnades.

From top: patio houses; offices; shopping; car parking.

Figure 5.8

Wood Green urban infill factories, London 1979–81.
Perimeter wall, a banded brick wall interrupted by upper-level windows enclosing a courtyard with all-glass facades.

Figure 6.1 The Crafts Council Gallery, Waterloo Place, London, 1980–1.
A conversion and extension of existing premises.

Figure 6.2

Clifton Nurseries, Bayswater, 1979-80.

Exterior view from the garden centre side. This temporary building sat next to my earlier project, the Colonnades.

Figure 6.3 **Clifton Nurseries, Covent Garden, 1980-81.**

After the success of the first Clifton Nurseries I was engaged to design a second temporary building on a short-term lease site in Central London. The exterior demonstrates a relaxed and light-hearted architectural approach that sought to echo the surrounding architecture.

Figure 6.4

The Jencks House, 1978–81, also known as the Thematic House, was Grade I listed in 2018.

It was a grand stucco-fronted Victorian property that I worked on with both Charles and Maggie, the owners, who wanted the house to reflect the cosmos, solar system and seasons. The house is a series of set pieces with personal decorative work added over the years.

Figure 6.5

TV-am building, 1982, which sits alongside the Grand Union Canal.

Figure 6.6

Hatton Street offices, top floor prior to office refurbishment.

This space later became my home.

Figure 6.7

Exterior of Hatton Street offices, complete with 'wings' harking back to its incarnation as a Palmer Aeroworks.

Figure 6.8

My flat at Hatton Street, which was originally used as offices for the practice.
I later lived in it for 20 years.

Figure 6.9

Charing Cross/Embankment Place.

Its suspension structure air rights building is now an iconic Thameside landmark.

Figure 6.10

Section of Charing Cross/Embankment Place, 1987–90.

Showing the deep piles, the underground railway lines, the arched roof structure and Villiers Street and gardens adjacent.

Figure 6.11

Alban Gate, London, 1992.

An air rights building across a major road, London Wall. The cross-bracing in the centre was part of the design to provide lateral stability and enclosed the two six-storey atriums.

Figure 6.12

Alban Gate, London, 1992.

Housing to the rear, on Monkwell Square, with our landscaping in the foreground.

Figure 6.13

Vauxhall Cross/MI6 Headquarters 1988–93.

The riverside elevation with its concrete cladding assembly structure, which seems to be standing the test of time; a factory-made project in exuberant dress.

Lives in Architecture: Terry Farrell

Figure 7.1

The Peak, Hong Kong, 1995.

A twelve-storey building in a hill-top city-wide context, which is also the topmost station for the funicular tram. Competition stage model.

Figure 7.2 **British Consulate and British Council, Hong Kong, 1996.**

View from Hong Kong Park, showing the building sitting within landscaped gardens.

Figure 7.3

Kowloon Station masterplan, Hong Kong, 1992–2011.

3D concept drawing showing a cross-section of the station development. The second air rights development took ten years to complete, and this drawing shows the Hong Kong island skyline in the background with our Peak building at the top centre.

Figure 7.4

Kowloon Ventilation Building, Hong Kong, 1995. View from Victoria Harbour.

The project required a functional building to be integrated into a public park setting, but allowed us great sculptural scope.

Figure 7.5

Edinburgh International Conference Centre, 1995.

A distinctive drum-like form landmarks the site within the Exchange District also masterplanned by Farrells.

Figure 7.6

Beijing Opera House Competition 1999.

Fourth stage scheme showing cross-section through foyer.

Figure 7.7

Incheon Transportation Centre, Seoul, 2001.
Rooftop aerofoil symbolising a bird in flight, providing natural light and ventilation.

Figure 7.8

Incheon Transportation Centre, 2001.
The Great Hall: whether arriving or departing, passengers pass through this great glazed arched space.

Figure 7.9

Dean Gallery, Edinburgh, 1999.

Cross-section. The project utilised an intense palette of colours, combined with a series of Surrealist-inspired spaces to surprise and intrigue the visitor.

Lives in Architecture: Terry Farrell

Figure 8.1

Petersham houses, 2006. Aerial view.

Three contemporary homes in the southwest of London. Each house designed to enhance light and space while remaining immersed in the courtyard gardens.

Figure 8.2

Thames Gateway: The Parkland Spatial Framework masterplan drawing, presented in 2008.

My vision for the area is to regenerate and develop urban and rural open spaces which are connected together to create an accessible and coherent landscape.

3 South Essex Marshes
Canvey Island
Corringham
Coryton
Fobbing

17 Stonebridge Park
Southend - on - Sea
Shoeburyness
Wakering
Southchurch

WALLASEA ISLAND

Canvey Island

RIVER THAMES

PENINSULA

16 Allhallows Marshes
Grain
Allhallows
Stoke
Kingsnorth

Sheerness

18 Sheerness - Minster Marshes
Sheerness
Minster - on - Sea
Queensborough
Halfway Houses

ISLE OF SHEPPEY

22 Isle of Harty
Warden
Eastchurch
Leysdown - on - Sea

RIVER MEDWAY

THE SWALE

Sittingbourne

Faversham

15 Capstone Valley
Chatham
Gillingham
Walderslade
Park Wood

19 Sittingbourne Park
Sittingbourne
Kemsley
Murston
Milton Regis

20 Teynham Park
Teynham
Lynsted
Conger
Mockbeggar

21 Faversham Park
Faversham
Uplees
Dargate
Graveney

50 60 70 80km

Lives in Architecture: Terry Farrell

WATERFRONT CITY PLAN OF P

5: GRANTON HARBOUR
- IDENTIFY SCOPE OF NEW DEVELOPMENT
- REVIEW FORTH PORTS' PROPOSALS
- INTERFACE WITH WATERFRONT EDINBURGH
- POTENTIAL CONNECTION TO PORT OF LEITH
- MASTERPLAN STATUS • ROADS/TRAM STOPS
- USE OF HARBOUR
- UNALLOCATED SITES

3: PORT OF
- IDENTIFY SCOPE O
- REVIEW UNDEVELO
- STUDY ALL WATER
- EXAMINE PHASI
- INTERFACE W. RAIL

CRAMOND

WESTERN HARBOUR A ★

6: GRANTON
- IDENTIFY SCOPE OF NEW DEVELOPMENT
- REVIEW WATERFRONT EDINBURGH'S PROPOSALS
- INTERFACE WITH FORTH PORTS
- MASTERPLAN STATUS
- EXISTING BUILDINGS REGENERATION
- PROSPECTS FOR ADJOINING DISTRICTS
- LINKS TO W. EDINBURGH
- SECONDARY LATERAL & LONGITUDINAL ROUTES
- WESTERN EDGE OF BUILT-UP AREA

4: TRINITY WATERFRONT
- VEHICLE CAPACITY OF FRONTAGE
- ROAD/TRAM RELOCATION OPTIONS
- EXISTING BLDGS STUDY
- LAND RECLAMATION
- POSSIBLE CAUSEWAY
- TRAFFIC STUDIES
- IMPACT ON TRINITY
- SECOND WATERFRONT STUDY
- WATERFRONT VIEWS/ACCESS
- AS CLOSE TO CHARLOTTE SQUARE AS ARTHURS SEAT IS

- ASSESS HOUSING ALLOCATION [3K IN WESTERN HARBOUR ALONE]
- LARGER THAN OLD AND NEW TOWNS COMBINED

CENTRA

OWNERSHIP
3 & 5: FORTH PO
6: WATERFRONT ADJACENT SECT
STUDIES BY INCU

Figure 8.3

Edinburgh design champion, 2004–8.

Plan of plans – the key to the masterplan tiles, which primarily followed the projected future tram routes.

19 October 2004

1: Seafield
- Lateral permeability
- Waterfront access
- Sewage works status
- Bus station status
- Former Marine Gardens site research / investigation
- Review promenade access from Portobello to Leith
- Beach contamination / ecology
- Alternative locations for warehouses
- Other appropriate uses
- Almost 3km of inaccessible frontage previously accommodated gardens & a sports arena

(left margin)
- Development tes opportunities
- Port dev'nt
- N Roads/Bridges
- Newhaven regen
- Dock & ship activity

2: South Leith
- Old Leith / Port of Leith interface
- Tram stops location
- Commercial St. permeability
- Development opportunities to E & W of Leith Walk
- Green spaces & routes / boulevards
- Buildings survey
- Water of Leith opportunities
- Traffic study from Port → Princes St.
- Identify original waterfront blgs.
- This zone was previously Edinburgh's waterfront

0 — 1 — 2 KM

Figure 8.4 The Deep, Hull, 2002.
A landmark millennium project. View from the River Hull of the observation point at the junction of the river with the Humber Estuary.

Figure 8.5 Home Office, London, 2005.
The confident and bold entrance with glass canopy designed in collaboration with Liam Gillick.

Figure 8.6 Great North Museum, Newcastle, 2008.

Redesign of a Grade II* building with new extension. Revitalised existing galleries improve the conservation, display and interpretation of the combined collections.

Figure 8.7

KK100, Shenzhen, 2011.

Winner of an international design competition, KK100 held the title of tallest building in Shenzhen from 2011 to 2016 and remains the tallest tower ever realised by a British architecture firm.

Figure 9.1

Kennedy Town swimming pool, Hong Kong, 2017.

Built beside the sea on an existing car park area.

Figure 9.2

M+, Hong Kong, ongoing construction. Gallery and Museum of Visual Culture in collaboration with Herzog & de Meuron. Scheduled to open in 2021.

In the background is the Kowloon Station development (masterplanned by Farrells but built out by other architects).

Figure 9.3

Chelsea Waterfront, London, 1996–ongoing.

A residential-led mixed-use development. The only major development site of its size on the north side of the river west of Canary Wharf. The scheme includes two towers of 37 and 25 storeys, and low-rise apartments situated on the river's edge surrounded by landscaped gardens which are publicly accessible.

Figure 9.4

Beijing South Station, 2009.

Natural light filters through the photovoltaic skylights illuminating the Departures Hall.

The 1980s

By May 1980 I was formally all on my own, as we had all the complex legal agreements which had formed and united Farrell/Grimshaw out of the way. But in the end the legalities didn't mean much, because it was like any separation, with legal and financial consequences that were gradually but inexorably ignored over the years, as we got on with life.

During the first few months of 1980 we co-existed in the offices because I had agreed that Nick and his team could stay until they had an office of their own. It took until May 1980 for them to go, and it was only after they finally left that things really deteriorated between Nick and me. Initially perhaps this was because I created a stir by capitalising on two projects that successfully inspired the back-page headline in *Building Design* on 6 June 1980: 'Forecast Favours Farrell's Future'. I know it riled Nick's team as they had described us as 'dead wood', which we clearly weren't! It was also reported that we had just won the joint Town and Country Planning Association and the *Guardian*'s 'Tomorrow's New Community' competition with a low-tech yet knowing tech-design vision of future low-energy design.

I had taken on some office tenants, anticipating that after the split the office would be half full, and started an independent practice with Ralph Lebens, who was working with passive solar energy. The 'Tomorrow's New Community' competition predicted a modern world in which passive solar and eco-concerns would be much more dominant, but by adaptive and passive means we could help overcome the emerging difficult circumstances regarding energy use and global warming. This was

novel thinking at the time, and I energetically looked for alternatives to counter the technological determinism that had been the image of the practice hitherto. And so instead of a hugely glossy wrapping-up of the content, our competition entry was the opposite in that it was hand-drawn with comic-book-style illustrations that harked back to *The Beano* and *Dandy*, and had an immediate, accessible appeal.

An open-mindedness had been growing within architecture throughout the 1970s, epitomised by the community architecture and conservation movements, in response to increasing recognition of the pluralist voice of the general public. It was a time of continued re-evaluation, and of a belief in what can only be described as an attempt to give architecture a social conscience. I had joined with Covent Garden Market protesters intent on saving the market and surroundings from demolition, and had become involved in projects like the Comyn Ching Triangle. Fed up with opinionated, single-minded focus and particularly 'sheds', my work was instead stimulated by ecological concerns and an interest in Postmodernism with its popular symbolism and particularly its ornamentation – a direction that seemed to fly in the face of puritanical Modernism (as it had become).

* * *

During 1979–80 I had taken on a teaching post and became a unit master at the Architectural Association, followed by a stint in the autumn of 1980 teaching at the University of Pennsylvania. Modernism didn't and still doesn't do interiors (as the rigid rule is that inside and outside are 'consistent' and reflect each other); I also decided to do independent interiors. For example, I created interiors and fit-out for Digital Computers in an off-the-peg existing shed. Later that same year I took on the Crafts Council Gallery interiors in Waterloo Place, and of course there were my own office interiors: I took delight in their expression being completely different to Farrell/Grimshaw's interiors, in the same space (Figure 6.1). The introduction of my personal expression meant that my work and visual aesthetic were now becoming very noticeably different in taste and style.

Conversions, ad-hoc improvements and alterations fascinated me. 'Learning From Chigwell' – a play on the title of Denise Scott Brown, Robert Venturi and Steven Izenour's famous 1972 book *Learning From Las Vegas* – was a visual examination project of popular culture and taste that I set my AA unit students, and I fed this thinking into my own social housing commissions, such as at Oakwood 18 and Oakwood 13 in Warrington. Here we allowed for subsequent adaptations by occupants and incorporated hand-made sunburst doorway designs. These projects taught us a lot about popular taste and what people did in the socio-economic group straddling working class and lower middle class. So much of social housing is devoted to the self-serving architectural community's taste rather than the taste of the occupiers. The work of many architects at this time repeated this approach, which is why architects and the middle class generally, but not necessarily the tenants, identify with the profession's taste of the Trellick Tower, the Barbican and the Alexandra Road estate in London, and Park Hill in Sheffield. These postwar estates have all become slowly gentrified and more middle-class. I agreed with Prince Charles's diagnosis of just this

weakness of modern architects, as expressed in the Hampton Court RIBA speech in May 1984. However, I did not agree at all with his prescription, which culminated in his selection of designs for Poundbury in Dorset – a project I saw as a return to the 18th century.

* * *

Now I had connections and was a person of privilege, because working on the Jencks House had meant getting to know Maggie Jencks, who had then introduced me to Jacob Rothschild. Rothschild wanted to focus his ambitions as an emerging architectural patron on a temporary plant nursery building that would create a stir. I registered that his ambitions were aligned with mine and we both wanted a signature project to announce our arrival. So, in 1979, I had agreed to a £100,000 fee at 6%, meaning that we got a mere £6,000 for designing and supervising it all. We probably spent two or even four times that much on the project to get it home. By a quirk of fate, the site for the Bayswater Clifton Nurseries pavilion (Figure 6.2) – the first job I completed under my solo name, in 1980 – was the still-vacant plot that had earlier been earmarked for the ultimately unbuilt public library next to my first large-scale urban design project, the Colonnades.

A headline to an article by Deyan Sudjic in the *Sunday Times* colour supplement in the early 1980s described me as 'The Man Who Took High-Tech Out to Play'.[15] Although in that case the article's focus was TV-am (which comes later in this chapter), the description could equally apply to the first Clifton Nurseries building. It demonstrated innovation in terms of passive solar energy without any mechanical parts; the stronger the sun, the more it self-ventilated. It was fun and joyous on site because we built the arches and entertaining elements that people could relate to for their decorative, non-functional qualities. It encapsulated an optimism which was badly needed at the time, as High-Tech and Modernism had become so earnest, functional and dry: in addition to Grimshaw's sheds, there was now also Foster's HSBC building in Hong Kong which, as wonderful as it was, nevertheless seemed an incredibly difficult feat, and made a simple office building into a titanic piece of engineering. As did, in the same way, Rogers's Lloyd's building in London with its external lifts and plumbing – the engineering and apparent utilitarian functionality was a dominating, even bombastic, overlaid ornament in all their work. By contrast Clifton Nurseries, completed less than one month after the Farrell/Grimshaw split, was a lightweight palace, described by the *Architects' Journal* on its cover as 'Terry Farrell's Crystal Palace'.[16] (It also achieved the cover of the *Architectural Review* later in the year.[17]) We had very good photographers in Jo Reid and John Peck and I promoted the building shamelessly; it became enormously publicised and well known. (Figure 6.3)

* * *

I think the gap between Nick and me, after being partners for 15 years and close friends for 20, accelerated because of my immediate success. My teaching at the Architectural Association and the success of the early projects attracted younger

staff, and several students who would work for me part-time had rooms in my house. As both Steve Marshall (of Munkenbeck & Marshall) and Clive Wilkinson (who now designs for Google in California) commented at different times, they had a job they loved and accommodation all in one package. I set about two strands of expression/identity in architecture. One strand was taking High-Tech out to play, as exemplified also by the Wood Green industrial estate, Alexandra Palace temporary pavilion and the Water Treatment Centre at Fobney for Thames Water, all completed by 1981–2. The other strand involved exploring Postmodernism, with the Jencks House continuing throughout this period. (Figure 6.4) To say I was wary of Charles's intention to promote himself as an architect when it was all finished would be an understatement. However, the house has recently been listed by Historic England as Grade I and, much as I joked at the time that Charles was keeping a file of all his drawings and contributions, and that he was more of a Post-Rationalist than a Postmodernist, Charles was always generous and reasonably fair about the whole business. Collaboration is a funny thing; it raises the issue of architectural jealousy. There is a joke that starts: 'What do you call a collective group of architects?' The reply is 'A jealousy of architects', and there is no doubt that collaboration is not easy as there is invariably a clash of egos and different intended or hoped-for outcomes. When I went into masterplanning and urban design I felt this was particularly the case because I became the client's adviser as to which architects to select. Architects were invested in a kind of jealousy, envy and competitiveness that really precluded many from collaboration and cooperation. I observed that buildings in their habitat of the city, town and village were well settled into a townscape or streetscape, part of the background scenery for everyday life; and I was aware of something like sociopathy that architects brought to every project as they wanted their buildings to stand out, be noticed, be different and display heroic individuality. Yet here I was arguing for contextuality, community and learning from history, which from earlier on in my career I had always described as 'the work of many hands'.

Nowhere did this come out more than in my work at Mansion House, demonstrating – in the spirit of Covent Garden – that adaptation and conversion was the norm, a good thing, creative and highly courageous. The work of English Heritage was very interesting to me and so I was delighted in 1984 to be invited to be on the London Advisory Committee, which was set up in advance of the GLC's demise. I arranged to meet Marcus Binney, the head of SAVE Britain's Heritage – the independent lobby group set up to prevent major demolitions of historic buildings. By pure coincidence Richard Rogers rang me up just minutes before I met Marcus, and Rogers assumed we were all in 'the club' together and believed that all modern architects would support, as a matter of principle, the Mies van der Rohe proposal for a Modernist tower block to replace the existing buildings on the site. The more he spoke, the more I felt that the assumption that we were all like-minded members of the same club wasn't obvious or even correct. Immediately after this phone call I went to my office reception, met Marcus and recounted the Richard Rogers conversation. Marcus then announced over lunch that he had come to see me to draw up a scheme that defended the existing buildings and to demonstrate that they had a future life and that they were every bit as good as, if not better than, a retained group of buildings. With a new energy I

came up with concepts and advocacy that, although there may not have been a single listed building among them, collectively they were Grade I as they were a unique group and wonderful examples of the historical City of London. I demonstrated through my developing scheme how they could all be retained and began some of the formal arguments that I was to use again and again. For example, I argued that the new proposed Mies building was of one colour only (brown) and only two materials, glass and steel. It had only one door and only one expression, contrasted with the multiple doors that were on the existing buildings, whose sculpture and eclectic use of many materials including a range of brick, stone, slate, timber, tiles and glass gave the widest scope of colours and textures. Learning from my first experience as an entrepreneur I was able to price and do rental calculations that could prove the retention of the building was viable. I successfully presented the scheme for appraisal at the subsequent public enquiry. I had the conviction and growing confidence that an architect's role is as an advocate for what they believe in.

This period of my work contained many entrepreneurial adaptations and conversions, which included Earlham Street, the continuing Comyn Ching project and the BBC HQ, and would lead eventually to TV-am, Limehouse and my purchase of Hatton Street for our offices. My Mansion House project had touched a nerve with the established way of thinking, particularly as I was advocating a solution without a fee and a client who represented merely a lobby group. William Rodgers, who was the director general of the RIBA at that time, rang me up to persuade me not to do Mansion House as I didn't have a client so I must withdraw. He used the expression 'for the good of the tribe'. Appalled at this notion, I went ahead regardless, and perhaps his opinion motivated me to be more contrarian. I began here to formalise the notion that 'place' and city-making was the more genuine client, and that advocacy on its behalf was an architect's duty.

* * *

TV-am began by the end of 1980 with an enquiry that started somewhat randomly with my accountant then led to a client of his, a graphic designer appointed by the new breakfast TV company bidder, who then introduced me to the broadcasters Peter Jay and David Frost. The initial brief, on which they based their bid for the franchise, was to adapt an existing studio in Wandsworth. They won the bid on the strength of their commitment and enthusiasm, as it was seen as an equivalent to the United Artists of Douglas Fairbanks, Charlie Chaplin and Mary Pickford, all performers and stars known for being in front of the cameras and not behind them. But they didn't have much business sense and so didn't tie up the agreement with the Wandsworth Studios before they won the bid; and of course the price trebled once the studio owner realised they were the chosen franchise, and so they were 'trapped'. By then I was a part of their team and attended lawyers' meetings in Gray's Inn. It seemed that the only option, in view of the lack of time (as they had committed to be on air on 1 February 1983), was to do a deal with an existing facility. But I argued that a new breakfast TV station, a completely new venture on TV, ought to have a visual brand, a new immediately recognisable 'face' – like how the BBC News at 10 had Westminster Palace's 'Big Ben',

or how the American TV series *Dallas* had Southfork Ranch, a grand farmstead. There was a recognition in my argument for a definable 'place' that potentially epitomised, branded and gave a physical identity to the new station. (Figure 6.5)

Peter Jay, David Frost and co. agreed to let me do a parallel search option for a whole package of a builder, a site and a building. So I had it all worked out in advance that they would pay X for the site and Y for the fees and Z for construction with the builders. I chose Wiltshires, who were contractually committed to build it on time, and then we would have the best chance to meet their way forward. They accepted this and so the extraordinary, creative adventure that was TV-am began. Nobody who worked on it from my firm was over 30 years old. I gave one team the front wall and another team the atrium and interiors, while a third team worked on the back wall; these accounted for all the architectural elements, but I put a further team on the technical side of the studios. It was great fun, but – as I then commented – that equals sweat and tears in its creation. This was summed up one Saturday night at 11pm when I went past the office and noticed that the lights were on. I went in to find Peter Tigg sitting right at the back of the office and asked him what he was doing in so late. He said, 'I'm helping to build a TV station!' A very young architect at that stage, he was doing the nuts and bolts of a very obscure bit of the building, and he recounted to me the story of Sir Christopher Wren and St Paul's Cathedral, and how, when Wren noticed a light on in just the same way and went to enquire why, there was a man sweeping the floor. Wren asked what was he doing at this late hour and the man replied: 'I'm helping build a cathedral!' And Peter Tigg felt too that whatever the lowly element of his work, he was nevertheless involved in a great and worthwhile endeavour.

It all came together in an eclectic mix. I was entrepreneurially accommodating all the past experiences I – and the team – had accrued. For example, the process side of High-Tech in terms of the ability to get contractors on site and to work through the stages of construction in parallel with designing was all part of what I had learned and then applied to TV-am.

This was followed closely by Limehouse Studios. I don't believe that Limehouse or indeed TV-am were truly Postmodern – Bob Venturi once said to me, 'You don't do Postmodern, you do a more hybrid architecture.' He felt that TV-am showed more elements of Pop Art on the front facade and elements of Ad-Hocism and Postmodernism on the inside, while the back wall was entirely conservation architecture – I accepted and believed it was truly eclectic. At this time in the office there were projects of unabashed Postmodernism, such as the Jencks House followed by 76 Fenchurch Street, Henley Regatta Headquarters and the Queen Street offices in the City of London, but these were all part of the freedom and experimentation that went on in parallel with other varied expressions of architecture.

* * *

By the middle of the 1980s I'd started looking more seriously at urban design, such as at Hammersmith Roundabout where I pitted the retention of the buildings against the planning consent that Norman Foster had received. The Foster scheme was about 'bigness', with its ruthlessly proposed over-simplified answer to complex urban design

and planning problems. I delighted in advocating a counter-proposal, a non-heroic scheme which focused on the pedestrian experience and kept the existing grain and context intact. My scheme was adopted by the GLC and the local authorities but it then went backwards when the site owner appointed other architects to carry out the designs. Still, I felt vindicated, as my advocacy, urban designing and town-planning was thought to be more realistic, practical and humane. This focus continued in the 1982 competition for the Effra site, to the southeast of Vauxhall Bridge, for which I designed a large scheme that expanded right across in front of the Vauxhall roundabout and the River Thames. These, together with the Mansion House project, all became part of what I passionately believed in (and indeed the Effra project did finally bear fruit, in the second half of the decade, as described in the following chapter). The city itself was the exemplar, full of diversity, layered by many hands over time, including everything that made up neighbourhoods and societies, and all socio-economic groups. At this time, rediscovering this context and history was as important to my work as Postmodernism's stylistic adventures.

* * *

By the end of 1984 I had produced with Academy Editions (published by Andreas Papadakis, who also published the magazine *Architectural Design*) a monograph that I put a lot of energy into as it was the very first comprehensive book on my work.[18] But with no paying projects after the completion of the two TV stations in 1984–5, I decided to make my own work. I saw an opportunity in the form of a derelict factory previously used by the Palmer Tyre Company for making pneumatic aeroplane tyres, and which had closed in 1980. The building was on Hatton Street near Maida Vale, which I passed regularly when walking from our home to nearby Church Street Market to shop, and which had been continuously advertised for sale for two or three years. Conscious that the Paddington Street lease would be coming to an end in 1987, I enquired about the old factory, thinking that if I could take on a community of studios, offices and residential units, it might be possible to get my offices for free, and some work too. The developer turned out to be a speculator with no experience of property development. I challenged his ambition of selling the building off as separate floors, explaining that he wouldn't be able to do this as there were no combined plans for means of escape that could enable the subdivision of the property in a way that would be approved by building regulations and planning. He gave me his list of interested purchasers and I rang them to get them together with one or two other prospective buyers. I got the offices filled (in principle), then got options with the developer to proceed, with an expiration date in May 1985. On the due date I had a very anxious few moments signing contracts to purchase the parts of the premises with each of the 20 plus occupants, and I undertook to sell them as subdivisions with planning consent, building regs and means of escape – 65,000 square feet in all. I paid £650,000 in total, so it worked out at £10 per square foot, which was a fantastic bargain even though it was derelict. (It's worth in excess of £1,000 per square foot today.) This development was to occupy much of the small office's time, particularly in the first years after 1985. Little did I suspect then what a huge expansion the practice was about to experience,

and how inadequate the amount of space I'd planned to occupy at Hatton Street would be. (Figures 6.6 and 6.7)

* * *

It was very dramatic how our fortunes changed. Every year the whole office had a Christmas lunch together, and for Christmas 1985 we had booked a modest restaurant for the 15 of us left at the office, thinking we were about to run out of commissions and so it would be the last time some of us would work together. At that point we were working on a decorative scheme that Andreas Papadakis had asked us to do for his private house and offices at Leinster Gardens in Bayswater, and I had been preparing several possible major office projects in London: one in Red Lion Square, for Stuart Lipton; one above Fenchurch Street Station, for David King (Central City); one above Charing Cross Station, for Greycoat Properties; and one on London Wall, replacing the existing Lee House, for MEPC. But these were all semi-speculative schemes – as they covered some costs but didn't cover all our expenditure – and more seriously I didn't give them any chance of becoming real projects. I couldn't have known that they anticipated the 'Big Bang' boom in demand for large-scale office buildings, especially around Canary Wharf, which was about to come about as a result of the sudden deregulation of the UK's financial markets brought in by the Thatcher government in 1986. I was therefore drawing up a list that Christmas for further cuts in overheads and staffing.

Just before the Christmas lunch, we got the message that Alban Gate (London Wall) was looking more than likely. The first actual confirmation of that appointment came in about 12.30pm, and the lunch was booked for 1pm. I said to Doug Streeter, who was doing the drawings for Leinster Gardens, 'There's no point finishing that drawing for Papadakis, let's go and have lunch and it should be a celebratory feast to remember – you can finish the drawing later.' We had a fabulous lunch; the drinks bill exceeded the food bill many times over, and we didn't leave the restaurant until the middle of the evening.

There wasn't time to think of how we would cope with this new work, but early in 1986 I went to see Stuart Lipton and David King to tell them I couldn't do their projects because the office was overwhelmed and I had to make choices. I felt that the other two projects were extraordinary locations and opportunities, and although I thought Red Lion Square and Fenchurch Street were great too, I just couldn't cope with all four projects.

I initially talked to firms like RMJM and others about collaborating, with them doing the working drawings, but when one of the RMJM partners commented that he didn't mind taking in other people's dirty washing, I could see that while it's now more commonplace to divide up the work, back then it wasn't, and that we would not only be relegated to the B team for the collaboration, but more likely the C team. So I resolved to go with building up my own practice and taking on the challenge. As I was to find out, this would involve the office growing from 15 to 150 staff in just one year.

The offices in Hatton Street were not due to be completed until 1987, so we quickly found that lack of space was our first big problem. Managing space is a critical

entrepreneurial skill I'd developed for this labour-intensive business. To tide us over, we first negotiated agreements to compensate the tenants at our Paddington Street offices for leaving, and took over the whole of that space ourselves. Thus Paddington Street took 40 people. This office housed the team working on Tobacco Dock, which was a large conversion of a Grade I-listed early-19th-century warehouse in Wapping (designed by John Rennie). We had taken this project on as it was seemingly slower paced and the work seemed to need different skillsets, which preoccupied us alongside the new office projects. From Pell Frischmann, the engineers, I took on an additional temporary let on space that they had available from cancelled Middle East work – an office at Nottingham Place – until our new offices at Hatton Street were ready. I briefed the teams and put the Charing Cross team (which grew to 25 staff) on two floors and the Alban Gate team (which grew to 35 staff) on another two floors.

I experimented a lot with staff structure and team-building, but found myself floundering organisationally, and it wasn't until a new managing director, Ashok Tendle, who had worked as a civil engineer/project manager in the Middle East, joined us in the early part of 1987 that I felt I had the answer. Everybody hated his discipline and thoroughness at first, but he managed to get the teams in shape, and directed the work required. His influence and professionalism were a godsend and I am ever grateful to Ashok for what he did for us during that time.

I had to attend design sessions with my senior designers, who were all in their late twenties but who had been with me since 1980–1. Design sessions were broken down into several teams, something valuable I had learned from my time on TV-am: that process was as important as the product. Charing Cross was divided into four teams and likewise Alban Gate. However, by the spring of 1987 both projects stalled, which was intensely alarming as by then I had reached ten times the number of staff and had multiple rents to pay, on top of the fact that we were in the middle of converting Hatton Street to a new office home. Charing Cross stalled because the funders baulked at the financial risk involved and set off the developer looking for different backers, which involved me having to make many more presentations to prospective funders. Alban Gate stalled because the planning committee didn't want to give it consent. So I had two completely different problems that needed solving. Almost at the same time, the developers Regalian bought part of the Effra site at Vauxhall Cross – the downstream section, southeast of the bridge. They held a competition for the site and selected the three original competition finalists and three additional new architects. I kept faith with the old drawings that I had done in 1982 for the whole site, adapting and then resubmitting them for the second competition, unlike the other two finalists who did completely different new schemes. We were quickly declared the winner and I was greatly relieved that I had something for my teams to work on if Charing Cross and/or Alban Gate failed to materialise. However, by mid-1987 they were both back on track and I found myself with three big building projects to do. This kept us very busy indeed, but as the Effra site had slightly later design and delivery deadlines, I thought I would keep with them all and see how things developed. I should add here that I had done the original 1982 Effra competition because the RIBA president, Owen Luder, had rung me up and said he had negotiated the terms of the competition successfully with Michael Heseltine, and that there were few likely entrants so far. Though I had vowed

never again to do open competitions, I thought it sounded like my kind of odds! Now, a few years later, it had returned on part of the original site and it became a major project for us.

*　*　*

I was now running an office of 150 staff. At this point it is worth bringing the story of our staff recruitment evolution up to date. At Farrell/Grimshaw, we had begun by taking students on, on an ad-hoc, temporary basis, and so the habit formed of selecting from those we taught at the AA and the Bartlett, which included a lot of students who were near-contemporaries. Then, as we became established and proper employment was in prospect, we cast the net wider – although, as we were London-based, the temptation was to take on staff who were already nearby and had already established their accommodation and knew London. All that changed when I went into practice on my own, and particularly in the late 1980s when the number of employees was in excess of 100.

In looking further afield I was helped by establishing a stream of architects from Newcastle University where Harry Faulkner-Brown, my former final-year tutor, saw the final-year portfolios in his role as an external examiner. This became something of a tradition, and we have had many good employees who graduated from Newcastle with good degrees. One such wrote to me very recently, and I quote from his email: 'I remember sitting with you on the prow of MI6 shortly before completion, and you turning to me with a smile and saying "it's great putting up buildings, isn't it". Indeed it is [as they] will endure and influence generations to come … Thank you for your guidance, patience … friendship over many years.' It was Duncan Whatmore who wrote this, but it could have been written by so many who became good friends over time.

Many (like Duncan) left and set up their own practices, and have been successful. I often think that a family tree of practices spawned through multiple generations would be an interesting thing to set about doing. What I found was that there were projects we did which absorbed several generations of job architects who made huge contributions and succeeded each other on the same project as it went through several iterations in the office. MI6 (described later in this chapter) is a case in point – it began with Oliver Richards (now founder/partner in Orms) in 1982 as a competition for the wider Effra site. It came back in 1987 with new owners/client and was a housing scheme led by Gary Young (now founder/partner at Place 54 Architects), which morphed into an office scheme led by Clive Wilkinson (who, as mentioned, became founder/partner working for clients like Google in the USA).

During the detailing and construction of MI6 the two partners now leading Farrells's Hong Kong office met and today, some 30 years later, they are still the principles there in Hong Kong. It is a community of colleagues drawn together by work, but who eventually become friends – sometimes they even marry each other – or move on and become leaders in their own right. The London practice is now led by ex-Newcastle students (albeit 30 years apart), both originally northerners like me: Mike Stowell and Shevaughn Rieck. And so it goes on.

Without them there would be no practice at all, and they have all made their inestimably creative contributions. As Duncan Whatmore said of our profession of architecture and urban design, 'It has been great ... creating and implementing ... projects which will endure and influence generations to come'.

* * *

We all moved to Hatton Street in 1987, as planned; I had borrowed from the bank to do up our units and we were ready to go. I'd originally had my eye on 5,000 square feet for us, and rapidly had to recalculate the division of space because it wouldn't remotely accommodate the number of office staff we'd acquired in the meantime. The future of the Hatton Street premises was very robust and they underwent further considerable changes in the 1990s (more of which later), when I ended up living there in the space I had occupied as an office (Figure 6.8). I like to say I bought wholesale and bought back retail, as I had to pay the full amount for subsequent transactions as the practice grew and needed more space. Initially, in the late 1980s, there was a filmmaker, a film props company, us architects, an importer of Apple Macs, a shoe designer and also a fashion house (that was subsequently, after five years, converted into flats). We were a real community and I bought and sold extra spaces over time as I needed it in the neighbourhood. For example, in the late 1990s I took space on the corner which was later let to an art gallery called The Showroom at a subsidised rent; we became good friends with them and were involved with them on joint projects within the Church Street neighbourhood.

* * *

Tobacco Dock was a substantial and extraordinary product of those heady days of expansion and development. The story goes that the client was (as he told me) a trick horseback rider who was coming to the end of his performing days with the circus and had come up with the idea that the moat at the Tower of London would be a good place to perform jousts for the tourist crowds. The Royal Palaces diverted him in this endeavour and encouraged him instead to look at a warehouse in Docklands, about half a mile from the Tower. He duly found the building, got very excited and took his jousting enterprise, fully costed and schemed out, to the backers, but they were not interested and instead suggested he try a Festival shopping centre, as had been done in Baltimore, USA, and that they might fund that. So he came to us, and with English Heritage's collaboration the whole Grade I building was reassembled and reshuffled. It was a wonderful building project that continued for seven or eight years, but suffered hugely in the recession of the early 1990s. We couldn't fit all the staff in our new offices when we moved so the Tobacco Dock team stayed in Paddington Street for another two or three years. However, in the new Hatton Street offices we accommodated the three big urban projects and we continued through the late 1980s to design, document and supervise these on site.

The first of these to be completed – in 1990 – was Charing Cross (later renamed Embankment Place). I had begun this project with Geoffrey Wilson of Greycoat; he

was one of the best clients I ever had, and we became very good friends. He had a tough team, comprised mainly of Ron Spinney and Chris Strickland. I have already mentioned the hiccup we had with funding, but once over that the whole project proceeded well. I allocated the design team very carefully – I felt it was a project that was so exposed and in so prominent a position that we had to do well, and so I would need to be very personally involved. It had come to us on the recommendation of Colin Amery, who was the *Financial Times* architectural critic and the author of an essay in the Academy Editions monograph on my work.[19] When asked a simple question by Geoffrey – could he recommend an architect who was also an urbanist? – he recommended me. I got a call in early 1985 to come to Geoffrey's office to discuss the new project, which seemed pretty far-fetched at first, but Geoffrey went about it methodically and steadily and he gradually won people over – and then the project became suddenly very real because of the 'Big Bang'. I presented the plans to British Rail to get the air rights agreement underway and to Westminster Council many times to get the planning consent. (Figure 6.9)

We had initially designed a fairly fruity rooftop, but it had little substance in reality and construction. Then the engineer on Nigel Thompson's team at Arup (with whom I had developed a strong working relationship at this time) came up with a wonderful idea of arching the roof forms and suspending the floors from them. I went enthusiastically with their idea for this extraordinary structure, which allowed the rail tracks underneath to be relatively free of columns, with the added benefit of the suspended floors dampening the sounds and vibrations of the trains. The whole form of the building stemmed from this engineering strategy: the idea spread by some that its southeast elevation (overlooking the Thames) is a pastiche of a Victorian railway station is completely unfounded. Still, while its structure is very clearly expressed, its architecture does not rely solely on that expression of the engineering, as had become the norm in High-Tech. Instead, there is a huge emphasis on detailing of both the interior and exterior. Although we did not design the interiors of the upper floors – which were let to commercial tenants who engaged their own architects – we did do the major interiors such as the entrance hall.

Like TV-am, Charing Cross is a building that has a completely different architectural expression on each side. To the northeast, on Villiers Street, it was tied in with re-landscaping the adjacent Victoria Embankment Gardens and making the street itself the first shared street in London – pedestrians mingling with the traffic. Based on historical photographs of the Victorian street furniture that had been removed for road widening, we reinstated railings, colonnades and lamps that most people now assume are the original ones. Given the slope of the riverbank, we also provided a walkway so that pedestrians can go right through from the Strand and cross the river via the Hungerford Bridge without changing level. Underneath, the station's arches house various spaces including a coin market and two reinstated theatres.

I wanted the architectural effect to be joyful and fun – unlike the joyless Modernism that had occupied parts of the Thames riverside in preceding decades, such as the LCC Architects Department's Southbank Centre (1951), and YRM's St Thomas' Hospital (1966–76). Modernist architects saw their work as enablingly neutral: in their designs, it was the brightly coloured clothing and attributes of the people,

sometimes frolicking with balloons or kites, that injected interest and playfulness into otherwise anodyne settings. My influence came instead from the great palazzos along the river's nearby banks: the muscular Art Deco of Giles Gilbert Scott's two power stations (Battersea, 1929–35, and Bankside (now Tate Modern), 1947–59); the exuberant Edwardian Baroque of Ralph Knott's County Hall (1911–33); the monumental Arts and Crafts of Richard Norman Shaw's original New Scotland Yard (1887–1906); the Perpendicular Gothic of A.W.N. Pugin's Houses of Parliament (1840–70). All of these – like the later London Eye (by Frank Anatole, Nic Bailey, Steve Chilton, Malcolm Cook, Mark Sparrowhawk, Julia Barfield and David Marks, 1999) – have a generosity and theatricality that I believe is required of architecture when it is in such prominent positions and on such a grand scale. This is architecture as entertainment.

Still, for me Charing Cross began with the plan and the plan discipline – I designed the four cores outside the station as great towers to house glorious individual office spaces with spectacular bay windows and terraces for people to take some pleasure in their elevated skyline work environment, so the roof spaces were not just for plant rooms and service areas. The arch itself was an engineering solution, but made heroic and exuberant, stepping down from eight to six storeys above the tracks as it approached the river – genuflecting to the scale of the river, but orchestrated so that you could see the back arch and the front arch together as one piece. (Figure 6.10)

Charing Cross was a very tough project process-wise because we had a strict budget: we were required to go back and redesign any of the component parts – cladding, lifts, escalators and so on – if they exceeded package tenders and the overall targeted budget. We built it in a time of high demand for construction and we had agreed to carry out such redesigns free of charge. Homing in on the constraints as the finances came under pressure for each component part gave me a reality to work with, and this method of working suited me well. It was also a process that we were well used to – TV-am had also had an upper limit on cost and time. I remember Anthony Caro, the sculptor, saying of his collaboration with Norman Foster on the 'wobbly bridge' outside the Tate Modern that he couldn't do architecture personally because everything had to be decided ahead of time and there was no chance to change one's mind during construction. He liked to produce rough ideas and then change and adjust and indeed 'sculpt' the answer, and I like to take a similar approach, so in many respects the way I signed up to do the contract with Greycoat on Charing Cross suited me because I was always adjusting: I liked the sculpting element of it and seized on what I interpreted as an opportunity to mould and shape the buildings. Piers Gough was speaking about Charing Cross, but was also generalising about my buildings, when he said on many occasions, 'Terry's buildings end up better than the early drawings and get better and better with time but some other architects' definitely do not.' One example of sculpting was the roof cladding: we had the lead in the original specification to match the lead roofs of the adjacent buildings, but on the return of tenders it proved to be a very expensive item, and so we rapidly and radically had to adjust to achieve a much lower cost. We did this with profile metal, providing a much more utilitarian and almost High-Tech solution to the roofscape, and I think it looks better for it. My inspiration for this was looking at the rooftop of St Pancras station and realising that was profile metal, just as we proposed to use on Charing Cross.

At the beginning the construction work on Charing Cross was done between 1am and 4am, to minimise disruption to the trains. The result is a structural tour de force that won the European Structural Steel Design Award – earlier awarded to Farrell/Grimshaw for the service tower in the student hostel in Paddington, but the first time Farrells received this award as a solo practitioner.

* * *

Alban Gate had come into the office a few days before Charing Cross, but it took longer to build. Its structure is again largely a reflection of engineering necessity. It was over a road, and so had very little grounding for natural stability. Internal bracing and spanning of the road were deliberately made very strong architectonic elements of the tower – the bracing becoming part of the architecture of two four-storey atriums, and the transfer structure appearing boldly in the public walkways below. The atriums also act as passive solar barriers that reduce the heat-gain to the offices behind. It is a triumph of Arup's engineering, every bit as much as many a High-Tech building was, and indeed more so because this wasn't engineering as superfluous decoration but was a genuinely needed part of the architecture, reintegrated into it in a formal and disciplined composition. This whole arrangement of the cradle structure and the walkways below, the south-facing cross-bracing in the atriums and then the front and back two towers clearly and separately identified by an arched top, was also about creating variety in office accommodation rather than the 'stack-'em-high' repetitive architecture of the 1960s. The language throughout is a fairly stripped-back architecture of banded red stone, in the vernacular of modern offices but arranged heroically and symmetrically. (Figure 6.11)

A significant part of the building complex faces Monkwell Square. Here we replanned the central garden and designed the Lutyensesque brick and stone terraced houses, where we repaired the square from the damage of a 1960s scheme that had exploded it apart and had ignored the potential for enclosing and placemaking characteristics. I enjoyed using a different architecture for these townhouses – happily differentiating fronts and backs, so much so that many people think that these have been designed by different architects. (Figure 6.12)

This urban sense of making a street, composing a gateway and recreating Monkwell Square was all about placemaking gestures. It was an urban space-positivity that contrasted with the orthodox Modernist urban culture of objects in a landscape. It was more than a style: it reinforced place, context and space-positive elements of square, street and gateway. These arguments were pioneering then; today all these characteristics are integral to any architect's toolbox and thinking.

* * *

The Effra site southeast of Vauxhall Bridge went through various phases during the 1980s. The 1982 scheme had achieved planning consent for a certain height, primarily residential use, and we kept to that in our 1987 proposal for Regalian; however, by 1988 Lambeth Council had decided to change the criteria for planning purposes and

would now only give consent to offices, having opposed them beforehand. They had changed their policy on residential developments, as it would bring the 'wrong' kind of socio-economic group into the borough, whereas offices bring in business rates (and no voting rights) that help fund public infrastructure and public or social housing. We were therefore refused the residential application. We went to appeal, which took over a year. I gave the evidence at the subsequent enquiry: by then I was well used to being cross-examined and proposing our case for planning consent in an enquiry, and I have continued to do so since, as public enquiries became the norm for me around that time – even on community schemes where I made no charge. But the effect of the Effra public enquiry was loss of time, and by the time we had the consent, residential use was no longer economically viable. So Regalian's chief executive at the time, David Goldstone, offered it to the government, which announced it had need of a department HQ building and signed up very quickly, not just for the site and us but for a completed building, delivered to its detailed requirements.

This was a new experience for us and was definitely outside our usual way of doing things. Here at Vauxhall Cross we were being asked to design a building in advance and not to change it after the signing of the agreement at a very early stage. The whole thing was a very different process from the other two major projects, in that it didn't allow at all for developing and sculpting the project. I had agreed to limit the fee to a fixed amount on Charing Cross, and as a result that was a difficult project commercially for us. At Vauxhall Cross I was determined to avoid a repeat of this situation, so I quoted the fee to be a percentage of whatever the outcome on construction cost. But I was caught out again because the tenders were all coming in lower than anticipated, as the construction industry was much less busy at that time, and so we finished the project well below budget and we had to work the last few months for free. Much later, sometime in 1993, I was sitting in a hotel in Japan suffering from jetlag when CNN announced that the new building was to be the HQ of MI6. I had always thought it was for the Department of the Environment! The briefing sessions were all in code and if there was a question in Parliament about a new building for MI6, the Foreign Secretary was duty bound to reply 'I know of no such organisation'. However, when the KGB HQ was opened to visitors in the early 1990s as part of President Gorbachev's policies of Glasnost, it wasn't possible to hide our equivalent building. I remember that the head of MI6, 'M', whom I had a rare lunch with after it was completed, said the building did them all a favour because it was so in-your-face and spectacular it was hard to ignore, and so, for the very first time, the workforce were free to talk about where they worked to their partners, neighbours and indeed all the world. (Figure 6.13)

With MI6 I was very involved in the design side, in particular the quality and colour of the concrete and in trying to design out staining and weathering by traditional and 'classical' detailing using cills, cornices and elaborations. 'Painting with rain' was the aim. Sure enough, it looks technically reasonably fresh and clean today – more than 20 years later. It was also another palazzo on the river, but this time on the more utilitarian, once-industrialised south bank, which hadn't been built up permanently. It was on an empty stretch of the river, a blank canvas, as the 19th-century buildings had been cleared away long ago. Undoubtedly my stylistic inspirations were the two

relatively recent 20th-century Art Deco masterpieces by the between-the-wars eclectic architect I much admired, Giles Gilbert Scott, the designer of the power stations at Battersea and Bankside.

Coping with big construction projects didn't keep me from urban design and planning projects – in fact I was immersed in them and spent a lot of my time planning the conversion of parts of cities. I saw it as very much part of the culture of adaptation and conversion but on a much larger scale. Changing primarily post-industrial places, working with what was there, I researched the history and context, which is seen as fairly normal now. The red line around the site was ignored as I went very widely beyond that for inspiration and context – which was the opposite approach to most architects at the time, who concentrated on denying the context of the city and claimed their building was going to be uninfluenced by everything around it; they viewed the red line as a commercial limitation on their commission (and therefore outside their fees), and such projects as an opportunity to create a one-off look-at-me statement that had an authenticity, as they saw it, within the Modern movement. But we worked with the grain, to ensure the development was an integral part of the city.

* * *

During the 1980s we did masterplanning work for the South Bank cultural centre – a little over a mile downstream from, and on the Thames like, Vauxhall Cross – which accepted the premise of the existing buildings of the Southbank Centre and spent as little money as possible trying to tweak them. It essentially approached the site as a kind of bricolage, taking what was there, living with it and adapting and adding to it in an ad-hoc manner. Because the complex was centre-stage in London and very high profile, it occupied a lot of my time. I particularly remember a drawing I did of the West End, as part of the advocacy – of an area of Shaftesbury Avenue which was full of theatres and restaurants, and that was about equivalent in size to the site around the Southbank Centre. I compared and contrasted the two: the diversity and richness of the streets, the number of front doors, the buses and taxis on Shaftesbury Avenue, as opposed to the South Bank site where there were only about six front doors and there was no passing traffic and nowhere to go after the performance. It was a monocultural estate – very much in the manner of housing/industry/universities zoning of the immediate postwar period. I formulated an opposite view, that towns and villages formed in the city naturally; the average hospital had workers' quarters, a chapel, a mortuary, even main streets and shops – and the best planning recognised this. It was the specialist operators and architects who wanted the building to be monocultural. I took the example of Heathrow Airport, which has shops, offices, staff areas, hotels, a mortuary, a chapel, many front doors, a natural accumulation that displays much diversity of use over time, and I argued for this to be the same at the South Bank. It was not the right time, as such ideas were seen as commercial and Thatcherite, and I got criticism for supposedly wanting to fill the Southbank Centre area with Sock Shops and Tie Racks – which in fact I was not proposing at all. My intention had been for bookshops, restaurants and event spaces, all of which are now present

at the Southbank Centre to make it much more an integrated part of the city, as the marketplace is generally cheek-by-jowl with cultural institutions in all great cities, whether historic or new.

I began to be recognised as someone who had ideas about the city and talked the language of planners, and planners welcomed this. I was appointed on many masterplanning and urban design projects by the end of the 1980s. I had begun the Greenwich Peninsula; The Exchange, as it was eventually called, on an old railway goods yard in Edinburgh; Newcastle Quayside, converting it from docklands; and Brindleyplace in Birmingham, where factories had once stood alongside run-down canals. These planning projects were all about urban renewal and post-industrial regeneration of the inner cities, particularly in the North. I went on to masterplan in Hull, Manchester, Preston, Leeds, Blackpool, Stockport and Chester, transforming once-vibrant 19th-century cities that had been suffering from neglect since the industries had dwindled and jobs had disappeared, with many places standing empty and derelict.

I identified hugely with this situation. I had come from the far Northeast of England, and I once regarded London as a foreign place (almost overseas) – like my parents who, up until and including when I was at university, had not [even] seen very much of England, let alone left the UK. The North of England was always a different place socio-economically and culturally, as in the late 20th century it didn't share in any of the prosperity of the South.

* * *

I finished the 1980s having developed friendships with writers and critics; people who had developed skills as observers, who had positioned themselves deliberately as outsiders looking in on the realm of architecture and buildings, which was something I identified with. I suggested writing a book at the time titled *Buildings on the Couch*, where architecture was differentiated not stylistically but by psychological interpretation – for example, one or two High-Tech architectural projects from Foster and Grimshaw where you couldn't find the front door. Their buildings were essentially sealed. This interpretation method put Richard Rogers in a completely different camp psychologically: he was the 'flasher' exposing all the bits and pieces of the functions of the building and so on. I shared these ideas with critics and writers and was fascinated by how they were increasingly shaping and forming architecture. I mentioned Colin Amery earlier in this chapter, but there was also Peter Murray who had designed the magazine *Clip-Kit* in the 1960s and went on to found *Blueprint* magazine with Deyan Sudjic in 1983 (having worked on the *RIBA Journal* and *Building Design*). Eventually, in 2005, Peter would set up the resource centre and discussion forum New London Architecture on Store Street, which I always use as a wonderful exemplar of private enterprise with public backing, but above all communication about the built environment of London. I like communicating, and am interested in talking about the subject of cities, and edges, both merged and fudged, of buildings, architecture, people and streets, and so on. I enjoy the company of journalists such as Paul Finch and Jonathan Glancey. All these people can make or break you, and towards the end

of the 1980s they had a close involvement with what I did, and began to question Postmodernism as a style, suggesting that it had run its course. I was convinced, and still am, that Postmodernism as a style may have run its course, played itself out, but that the movement's underlying principles were indubitably relevant and are here to stay. In a way we are all Postmodernists now.

The effect post-1980s was to free things up, to shift to a much greater diversity of expression and choice. This phenomenon was increased by the sheer numbers of people involved in the creative arts, which has multiplied in recent decades way beyond anything that existed before. For example, there are vastly greater numbers of schools of architecture and a much-increased design profession. In the 1950s there were only the elite appealing to the elite: a small number of architects, artists and fashion designers designing for a relatively small group of informed and wealthy people. From the 1980s onwards, the numbers exploded on both sides: artist–providers and client–consumers. There was a considerable popularising of the arts, and some architects became household names: Norman Foster, Richard Rogers and later Frank Gehry and Zaha Hadid; indeed the sad, untimely death of Zaha in early 2016 was an international front-page story. In the course of this, the sheer explosion of numbers has meant there is ever-greater diversity, because convergence is no longer the norm.

However, at the end of the 1980s it was still largely the same people who were in charge, who were leaders. It was only those being led that had increased in number. As I celebrated the completion of the three big London buildings in very public positions, I had a sense that things had changed for me. It was primarily the popularisation of architecture and my advocacy of everyday public taste that had done it. But the profession of architecture was used to being elite, having a more refined taste that was dictated to the masses in top-down fashion, and so they set about regaining the ground that they had lost. I realised this when one night at the Architecture Club, where I was invited to speak as a guest, Julyan Wickham and others took me to task in a very public and dismissive way and I remember one of their questions being: What did I think of Walt Disney? Instead of putting him down, I proclaimed my great belief in Disney, that he had indeed been a very creative, inventive and pioneering man. This was not what the assembled guests of leading architects wanted to hear and it helped to confirm their prejudices – I had gone from hero to villain by the end of the 1980s and could see the change of taste such that it was claimed I had mirrored Thatcher and her government. I didn't feel in any way a 'child' of Thatcher, as I'd approached things completely differently and had an entirely different view of the world. But I suffered the prejudice, and in many ways the Architecture Club evening confirmed that I had less in common with other, predominantly London, architects, particularly in associations like the Royal Academy, the RIBA and the Architecture Club itself. By 1990 taste, fashion, the ephemeral things had changed, and I was not to get a new commission in London again for ten years!

The 1990s

The 1990s began with an almighty recession, which created unique challenges for me. We were going into reverse, with a shrinking business forcing us to let go of many staff and sub-let office space. On top of this there were enormous tax bills arising from valuations, timings, misunderstandings and the transfer of the Hatton Street property from the recently set-up company name. But my abiding memory of the beginning of the 1990s was that it was dispirited by yet another recession, the unpopularity that I was experiencing and having good staff leave me as project opportunities were drying up. It was a situation that was pointedly illustrated by the journalist Simon Jenkins when he said to me at the time: 'Terry, you have had your turn.'

However, things were about to change for the better. One day in June 1991, I was walking up the stairs in the office, feeling depressed about the situation I was in but saying to myself 'Let the phone ring and let someone from overseas ask me to do a job'. As I reached the top of the stairs, where my secretary Maggie sat, the phone rang, and she picked it up and put the call through to me. It was John Chen Miller from Hongkong and Shanghai Hotels saying he had read about my work in *A+U*, the Japanese magazine which a few months earlier had published quite a large article on my recent work.[20] He was drawing up a shortlist to redesign and rebuild a new Peak building in Hong Kong for the owners of the Peak Tram – the Kadoorie family. Of course, I jumped at this opportunity and said we would love to do it – he should send me all the particulars and count me in. I was familiar with Hong Kong from the world

trip in my student days (as mentioned in Chapter 4) and I had lived there for six weeks working on a competition for Hong Kong Land in conjunction with my classmate Cecil Chao in 1980–1. So I knew the site of Victoria Peak, which was an impressive viewing point overlooking the harbour, and that it housed the final stop of the funicular railway, Hong Kong's most popular tourist attraction. Prior to the railway opening in 1888 pampered colonials had been transported up the 400 metres in sedan chairs to admire spectacular panoramas of mainland China and experience the cooler air. I decided there and then that I would do everything in my power to win it.

We launched into the competition, with Arup involved at the outset as an integral part of the team, led by John Pilkington. We had intense design sessions in London, where I had an initial concept which I vigorously stuck to, as time was very tight. This concept was based on a photograph on a postcard of a harbourside view of the whole skyline, which I drew over. It was all subsequently cleverly explained to the client by Steve Smith in visual terms, and the design itself was developed with my design director Doug Streeter. My design concept embraced the symbolism inherent in the Chinese architectural tradition. The result has been likened to a pair of hands, a bird in flight and a boat. Whichever is most accurate, the proposed building with its curved bowl-like shape would make a visual impact when seen against the high, tightly packed, vertical tower blocks below in Hong Kong's harbour, as well as it being potentially an unmistakeable silhouette both during the day and at night.

It was all ready to go and I decided we would build a beautiful model and take photos of it. (Figure 7.1) I am a great believer in photographing architectural models, as this adds a completely different dimension to the model (a technique perhaps somewhat overtaken by today's computer-generated imagery). We were announced as the winners of the competition, and John Chatwin and I went over to Hong Kong to agree the terms of appointment in August 1991. Six weeks later I went to Hong Kong again with Steve Brown to leave him there to set up a temporary office in Arup's Rotunda office building in the district of Wan Chai and start searching for permanent office space. We were on our way to clinching the commission and to establishing a presence in Hong Kong by securing office premises there.

* * *

Enthused by all this I started to travel in the Far East, and on New Year's Eve 1991–2 to Singapore, where I had been exploring the possibility of another project. Next I joined my wife Sue and youngest child Milly in Bangkok and enjoyed a short family holiday, on a beach for a week. I then travelled to Hong Kong where I gave a talk at Hong Kong University and took the Trade Commissioner out for dinner afterwards at the Hong Kong Club with various architectural friends who were based over there, to try to get on the shortlist for the new Consulate building, which was going to be built as a result of the handover that had been agreed by the mainland Chinese and British governments.

This was a very intense time for me, travelling back and forth, as I was focused on securing the commission for our practice's expansion and to keep my team together. We made it to the final six on the competition for the Consulate project, then went on

to win it. The brief was complex, but that was something I and the team revelled in. There were three buildings which we maintained as separate identities by designing the Consulate, British Council offices and residential block each in their own distinct buildings. Our design set the two headquarters buildings at right angles to each other and linked them via a shared entrance pavilion. Our layout consciously positioned the buildings to maximise the views up and down the two main approach roads, which presented long and continuous public street frontages to the north. Its curved and stepped form means that the whole composition cannot be appreciated in its entirety from only one viewpoint. At street level it appears as independent buildings, although the aesthetic unity is maintained by the roof and consistency of materials. To the south between the two main buildings, we proposed an exquisite private garden. Our approach to the project embraced a complex interplay of opposites: open and closed spaces, solid and void, flat and sloping, public and private, urban bustle and natural tranquillity. I proposed an architecture that seeks not to oversimplify by paring down reality. Like the city itself, it is a building constantly in flux, providing a different face for each situation. This relatively low-rise development presents a welcoming face to visitors and contrasts against the surrounding looming tower blocks. I am particularly proud of this building. (Figure 7.2)

* * *

Within nine months, by May 1992, we had two projects in Hong Kong, and then the opportunity arose to do West Kowloon Station, with the offer of up to £20 million in fees for the winning firm. Our London office was getting quieter and we were laying off good staff, so we tried very hard to win West Kowloon Station. At that time I was an English Heritage Commissioner (a role I held for six years) and during a monthly meeting one Friday the secretary came in with a note – it was a simple 'yes', and with that we really were in serious business in Hong Kong. By the Monday we had already started work, with a team in Hong Kong sent from London over the weekend. It was negotiated in advance with individual senior staff and all brilliantly arranged by my MD, Ashok Tendle. I loved this high-octane, exciting way of working, and having almost too much to do suited me very well at this time. (Figure 7.3)

Ashok found an architect we were to work with in Hong Kong, as the local law required that we partner with an 'Authorised Person' who was able to certify building works there. The local practice, Bosco Ho, operated two storeys underground beneath a car park – very cheap office space indeed! They already had 100 staff but we would occupy joint offices with them, as they had space to spare. Ashok had meanwhile organised and agreed with all the staff that in the eventuality of winning, most of them would go to Hong Kong and leave London, as nothing much was happening in London. Those not going to Hong Kong took it as very much hire and fire because that was the way it was and that is the way architecture goes; a bit like the film industry, when the film is made (or the building is built) there are no guarantees of more work. We had finished Charing Cross and Alban Gate and we could see MI6 completing soon. We had agreed individual packages in advance with each of the staff going out to Hong Kong, covering the financial terms and rented accommodation, including arrangements

for spouses and children, all organised by Ashok in the eventuality that we won the project, as this was what he had been used to doing in large projects in the Middle East before he came to us.

The station project was part of a plan instigated in 1989 by the government in Hong Kong to replace its congested airport at Kai Tak with a £12 billion airport on the artificial island of Chek Lap Kok. The airport is linked to Hong Kong's business centre by a sophisticated road and high-speed rail corridor, the Lantau Area Line and Airport Express Line. The railway stations along this line also act as transport hubs and became platforms for compact city districts, all linked by the extensive railway line, which reaches as far north at Guangzhou on the mainland. In stark contrast to the incremental nature of most airport transport systems, direct links to the city formed part of the plan for the new airport, which led to a full-scale development of integrated road and rail access, with all the incumbent facilities. Even for Hong Kong this was a remarkable undertaking and would prove a resounding success: symbolising the city's political and economic significance, the airport has continued to attract ever-expanding levels of air traffic, while the rail infrastructure services the needs of business and tourism, as well as supporting this expanding metropolis. (Figure 7.4)

As well as designing West Kowloon Station, we also masterplanned the eventual air rights development of the project and were to be the lead consultants, coordinating the whole team with retail consultants, residential consultants, architects and engineers of every type and of course the Mass Transit Railway (MTR) and its system-wide design requirements. There was a great deal of overlapping complexity and a higher quantity of air rights development than for any other site along the new airport line. We designed the architecture of the station throughout the early 1990s and masterplanned the overall development, which was 13 million square feet. We handed it over in 2002, although it continued to be built out until 2012 by separate air rights developers – so it took 20 years from the first drawings to the full realisation. All this development was built on infill land in the harbour to the west of the Kowloon landmass itself. At the competition stage I had asked Mike Stowell – who is now principal partner, running the Farrells practice in London as part of the 2019 succession agreement – to go and see the site (I was under the impression initially that it was land-based); he replied, 'I would have to get very wet to do so.'

We went on to build up our offices in Hong Kong to over 100 people, including relocating 50 staff from London to do these three projects. In Hong Kong we were split into two offices: the underground offices at North Point, shared with Bosco Ho, for the work on West Kowloon Station; and our Ice House Street offices, found as a result of my and Steve Brown's office search earlier, for the Peak and the Consulate and any new work that had to be done separately.

* * *

Eventually, I had to face the issues of retraction back in London, where we had gone from 150 people to less than a third of that in one year. I had surplus office space there to get rid of, which I managed to do over the next two years, and had to look for work in

the UK for the much smaller London office in the middle of a recession. This required me to use all my reserves of resilience and fortitude in the face of what seemed like total rejection in my adopted home city of London.

We succeeded in expanding the masterplanning work in Newcastle Quayside, Birmingham's Brindleyplace and particularly in Edinburgh, where we set up a small office to work on the International Conference Centre (Figure 7.5) and eventually the Sheraton Spa Hotel. We also looked for work in mainland Europe and secured commissions in Lisbon, which continued for at least ten years. There, we worked with a local architect, Miguel Correia, eventually carrying out the Barreiro Ferry Terminal and the restructuring of Do Rossio Station, as well as the masterplans for Expo '98 and for the coastal area of the city which is still being built out today. I see the latter as a very successful project and one that chimed with my passion for unused or empty buildings to be seen as a resource – re-utilising all the empty sheds and industrial buildings that stretched along the quayside for about 12 km from the Expo side of the Tagus right up to the maritime monument. It was Lisbon's version of post-industrial urban regeneration.

Meanwhile, as a planner I was particularly interested in the Royal Parks Review Group, which I had joined in the early 1990s and was under the chairmanship of Jennifer Jenkins. I saw in it the opportunity to do something for London that was far-reaching. This was my opportunity to advocate for the notion of 'place as client' (although I didn't characterise the project as such at the time) on a large scale – the Royal Parks held the key (to paraphrase Louis Kahn) to being 'what they wanted to be'. The committee itself encompassed a broad range of skills and opinions, but I concentrated on the landscape design and town-planning side, and many of the suggestions were subsequently implemented, extending well into the next decade and beyond. Committee meetings were held regularly in the Old Police Station in Hyde Park, and I remember walking through the park formulating ideas for Park Lane, Hyde Park Corner and the Serpentine road as I went. I believe that all the parks are great chunks of trapped countryside in an urban scene, and that these parks and palaces continue to distinguish London from other cities. However we hadn't resolved the role of the monarchy and public access to the parks, nor had we dealt with traffic and pedestrian movement both within and surrounding the parks.

With the Royal Parks Review Group, the English Heritage London Advisory Committee and the work as an English Heritage Commissioner, I began to feel really motivated to keep coming up with planning ideas for London. This had all begun in 1973 with 'greenways' (Nash Ramblas) that had led to masterplans at Mansion House and at Hammersmith and Wimbledon town centres in the 1980s, and would continue through to the 2000s with the Euston Road project and my work on one-way streets and reuse of land in the Docklands. For me it was centred around and very much confirmed by my involvement in these committees. Over time many of these varied planning conflicts and opportunities have been resolved as a result of my proposals but invariably carried out by others, which I was relaxed about.

* * *

Throughout this time I continued to travel a lot to the Far East, and I remember one particular occasion in about 1990 in Tokyo where Cedric Price, Michael Hopkins, Peter Murray and I were to speak at a conference with Tadao Ando. After the conference, at which Jim Stirling also spoke, we went with Arata Isozaki to a maze of lanes to find his favourite sushi restaurant. I took my wife Sue, Michael took Patti and Cedric came with various additional Japanese guests. It was an event that exposed the British contingent as very funny, informal guests in comparison to the slightly stiff and formal Japanese hosts. At the restaurant I had difficulty sitting on the floor so lay instead, due to the broken leg I had sustained after my motorcycle accident when I was a student. Cedric managed to sit on the floor successfully, but in so doing split his trousers all along the seams, exposing his bum. Michael Hopkins took his shoes off and to Patti's great dismay exposed the holes in his socks – Patti said, 'Why did you wear those socks?' and he replied, 'I didn't know they had holes in them!'

We had flown to Japan over Russia, in daylight – a more northern route to the Far East than I was used to, as flights to Hong Kong flew over a more southerly route, invariably at night. I never really enjoy flying but I am fascinated by the wonderful cloud formations and spectacular landscapes and looking at cities from the air. As we flew over Russia, which took seven hours, I marvelled at the seemingly infinite wilderness and steppe stretching out beneath me, all so extraordinarily vast. I travelled around the Far East including Korea, Singapore and Malaysia, all the time looking for projects and expanding our base in the region: during the 1990s I went there six or seven times a year while running the office in London. My fellow directors, Ashok and John Chatwin, both left in the early to mid-1990s so I was running the whole show on my own by the end of 1994. I appointed our finance and legal expert, Brian Chantler, as my MD, and he still advises me today and is a good friend – I am very grateful to have him by my side.

* * *

By the time 1995 came around there was a different mood; I had to change and face up to the fact that the Peak and Consulate commissions were finishing and that West Kowloon Station would finish one day. I had to start retracting staff back to London, which was by then increasing in staff numbers, as we had work (albeit out of London) – the economy was growing again.

I had bought the ground floor of Hatton Street by then, next door at number 7 – part of the premises I had originally sold off to a developer, Paul Cook. I was now looking at consolidating the new premises. It took us 18 months to get permissions, but I was ready to face the consequences of people returning from their three- to four-year stints in Hong Kong, as they had only gone for a fixed period. On average most staff had been in Hong Kong about three years, and this particularly affected those with children who were returning home to the UK, to take up their secondary school education. I hadn't expected that I would grow two offices of independent abilities, and so faced the complexities of combining the two. Unfortunately in this instance it was problematic, with neither the returnees nor the incumbents being happy or feeling secure.

The remainder of the 1990s were taken up primarily with rationalising the office

organisation as the senior staff returned from Hong Kong to London. A major preoccupation was moving the office from the top floor of 17 Hatton Street to the ground and first floors next door, at number 7. This was completed by 1997, and at the time of writing the practice is still based there.

* * *

I still looked for work in the Far East. It was at that time that I started visiting South Korea and formed a long-lasting and fruitful professional relationship with John Davies, who headed up new work for Arup there. I have to say that Arup were a great companion and enabler for firms like ours over that period, as they encouraged our growth and expansion; I have rather lost touch with them now, and many other engineering firms have grown in prominence, but Arup are a very successful and much larger global company today. In 1995 I wandered the streets of Seoul with a portfolio of work which enabled us to enter various competitions, including one in particular with the Samsung ruling family, the Y Building project (they gave each project an initial instead of a name). Like the Peak, winning this signature building, which was a kind of clubhouse/ambassadorial office for the CEO of Samsung, enabled us to win others such as the H project and C buildings. The H project was initially masterplanned by Rem Koolhaas and was a joint venture with Jean Nouvel and Mario Botta. We were doing two of the buildings, they were doing the others between them, and we all ended up collaborating on the masterplan stage. It was a real adventure and I felt that we had arrived on the international stage.

We were frequent guests at the embassy and the offices of the UK Trade Commissioner in Beijing and Seoul, since we had spent increasing amounts of time in the region as our practice there continued to grow. We won a major arts library complex project for Guangzhou in China not once but twice (the reason being that the brief changed and the second competition was again won by us). The UK ambassador duly came on both occasions from Beijing to Guangzhou, with formal dinners and toasts on each visit. However, neither of our celebrated schemes was ever built, and a shopping centre designed by Arquitectonica now sits on the site.

We were getting used to the fragility of commissions in the region, and events in Korea and Beijing were to bear witness to these unnerving extremes. The first of these was a design competition for the Beijing National Theatre complex next to Tiananmen Square which went through many stages (Figure 7.6). We were paid properly for each stage, and when, in what was reputedly the final stage, it was agreed by the jury that we had won, it caused much celebration in our office. All that remained was for the Chinese President Jiang Zemin to see and confirm our appointment. However, the French had been lobbying hard for their finalist Paul Andreu, and on the final presentation in the Great Hall of the People at the International Union of Architects (UIA) conference things did not go well. The French came up with a completely new scheme presented by their Minister of Culture, and to make matters worse, the British had mistakenly bombed the Chinese Embassy in Kosovo the day before. All this meant that in the end the French entry was declared the winner. Such is the increased risk of operating far from home in a different cultural environment. However, we were

assured our efforts would not be in vain, and sure enough in the next decade we were to win several public projects in Beijing.

The second intense disappointment unfolded with a Korean client at this time, around 1998–9. We had won the commission for the European headquarters building for Samsung, in West London, which I felt we really needed, to announce our return to the London stage. I was enthused by it and committed a lot of energy to the project. The final stages were a competition with just us and Norman Foster. Until the last two weeks we were a bit undecided about which of the two options to go for, and rumours were circulating that Foster's scheme was far better than ours, but we pulled out all the stops and came up with a brilliant set of drawings and design scheme. I went to Korea and presented this, and we succeeded in winning the project. We visited Hounslow planning and economic development teams, had a triumphant dinner with them, and even started work on site and were well into the working drawings. However, it was not to be, as the Asian financial crisis in the late 1990s affected South Korea badly. The scheme was cancelled, the site was sold and there now stands the GlaxoSmithKline European HQ building designed by an American architect.

Due to the same financial crisis in the region in the late 1990s our other Korean projects for Samsung were mostly cancelled. However, one that did go ahead was Incheon Airport Transportation Centre, or an amended version of it. The early designs were based on a bird in flight, a crane, represented by a control tower with a slender bird-like neck elevated above the roof upon a great hall below. Most of this eventually went, but the great hall with a clear span of nearly 200 metres stayed and formed the heart of the overall project: it is the central space through which all passengers pass. A key inspiration for the design was the Grand Central Station in New York, where technology and formality were both pushed to their limits in pursuit of awe-inspiring and beautiful but functional public space. (Figures 7.7 and 7.8)

A freestanding structure between two passenger terminals, the six-storey transportation centre is the airport's primary transport interchange facility. Integrated into the airport's infrastructure, it services around six million passenger routes a year. A colossal 250,000 square metres in overall measurement, it houses five rail systems (metro, standard train, high-speed and local passenger trains linked to the airport business centre); a bus and coach station; a taxi rank; and car rental, hotel and tour bus pick-up points. It also provides for complex parking requirements (passengers, general public, employees, taxis, rental cars and buses). The building was completed in time for the 2002 Football World Cup.

One phenomenon of this project is that it was designed in the UK by the London office, the engineers were based in Los Angeles, and the immediate client, Samsung through the Samwoo site team, was in Korea. As a result there was an eight- or nine-hour time difference between each team, meaning this project was able to deliver 24-hour working: we sent our work to America and they in turn sent our combined input on to Korea, following the rotation of the Earth and the daylight hours. The Korean client felt they had the best of everything, as they said they had European design flair, American organisation and technical prowess and Korean attention to detail and local application.

Back home in London, we were once again beset by disappointment. After we started on site for what was to be the largest office building in Wales, Bank One, the client was bought out by an American firm that decided to cancel the project. A planning application for the Three Quays, a hotel next to the Tower of London, was refused, and the business school won in a limited competition for Glasgow University at Kelvingrove was also cancelled. However, this is the architect's lot: commissions ebb and flow and are constantly subject to change. The ability to see clearly and react are skills that are not learned at architecture school, but rather in life, learned in practice.

I think, looking back, I was spreading myself too thin. I had forgotten my own advice to myself, as a younger man in 1970: focus and choose which projects you want to get hired for. I was getting enquiries from all kinds of places such as Seattle, USA for a new aquarium, which we won but which was also eventually cancelled because of the earthquake of 2000.

It was a similar story with a major new library in Dubai which was UNESCO-backed, a new station in Västerås, Sweden and various opportunities we thought we had in Berlin and elsewhere in Germany. We tried to build an aquarium in London's Docklands, in Silvertown, twice over. But gradually I realised these were not going to come about. The lack of success brought its own downturn in our fortunes, and I decided to concentrate on fewer projects and to undertake these in the UK.

By the end of the 1990s I started again with what I knew best – masterplanning projects, and architecture that emerged from these. I was professionally involved at that time with Godfrey Bradman, an astonishing, obsessive entrepreneur operating primarily in London. But all his schemes seemed unnecessarily complicated, and so, despite having started work on two projects together – one at Lots Road in Chelsea and one at the Home Office – we parted company. Eventually both of these projects became realities for us, but with different client bodies, and they continued well into the next decade, but any one of ten projects we were doing with Godfrey could have gone the same way.

Also by this time I had begun to be interested in large institutional masterplans, advocating that while they were invariably perceived as specialist places at the outset, they always ended up accreting the DNA of placemaking. Whether they were major hospitals, airports or universities, they reverted to gathering and assimilating all the elements of villages, towns and even cities – with uses added such as shops, housing, entertainment facilities, hotels and even mortuaries for the dead and clinics for the living. Accompanying these was shared infrastructure that could include car parking, mini power stations and civic phenomena like streets, squares and public gathering spaces. I had started the 1990s helping and leading the West London Hospital Board to decide and select sites for their future plans for University College Hospital and Westminster Hospital; by the middle of the decade I was masterplanning Keele

University; and at its close I was appointed as the masterplanner for Newcastle University where I had spent my undergraduate years.

* * *

The last project completed in this decade was a return to conversion of a specific building in the form of the Dean Gallery (now Modern Two) in Edinburgh, which was an adaptation for the National Galleries of Scotland of a fine former orphanage building from the 1830s by the Scottish architect Thomas Hamilton. I and my Scottish office immersed ourselves almost completely in this project for a while. Inspired by precedents like Sir John Soane's Museum at Lincoln's Inn Fields, I wanted it to be an art gallery that was as opposite to the austere white box as possible, and to my pride and delight a successful, colourful and abundantly decorated gallery resulted. It was an additional masterplanned campus that also embraced the Scottish National Gallery of Modern Art (now Modern One) opposite, new entries and exits for pedestrians and cars, and external landscaping including a landform sculpture by Charles Jencks. (Figure 7.9)

I experienced the whole spectrum of my career the day the gallery opened. I travelled to Edinburgh via Newcastle and went to visit St Cuthbert's, my old school. It had changed very little from when I had started there 50 years before; I met the art master who bewailed government cutbacks and said he hadn't the art materials that the pupils needed. His lament moved me deeply as this was where it had all begun for me. Then I travelled on to Edinburgh to the Dean Gallery opening. They had erected a very grand marquee and hosted in it a lunch for over 100 people. There were medals given out, and the First Minister for the new Scottish Parliament, Donald Dewar, opened the building and spoke at the lunch. What a contrast between the haves and have-nots. I was astonished at the different 'art' worlds; the whole experience had a lasting effect and influenced me greatly as I prepared for the next decade, in which I would devote much time to planning for the everyday, the ordinary – the man in the street, coping with so many impediments that architecture and planners could help with.

* * *

The year 2000 saw us still vibrant and relevant but facing a different world. There existed by then a much more competitive architectural scene – many other firms had grown up. We were seen as established, and younger firms had started to flourish in the 1990s. I intended to fully withdraw from Hong Kong as the office was haemorrhaging money. However, two of the architects there, both very much associated with the delivery of schemes – Gavin Erasmus, a project manager, and Stefan Krummeck, who was an architect through and through – decided to stay in Hong Kong and make a go of it. They approached me to say they wanted to keep the office going and look for new work, and I agreed, provided that they shrank right down to their base at Ice House Street and completed the finishing stages of West Kowloon Station. From that small base Hong Kong grew again. Of course it had had its ups and

downs, but by and large it has been very successful – and has introduced me to the idea of succession.

In 2000 I also moved out of my family home in Maida Vale when I separated from my wife Sue, and the only child still at home was my daughter Milly, then a teenager – the two older boys, Max and Luke, having left. This was a period of anxiety and turmoil for me as I moved into the former office space in the top floor of number 17 Hatton Street, which I call The Studio, or Flat 6. To cover the debts we had with the bank, which had left me with a 100% mortgage on the premises, I had sold the freehold of number 17 to a developer who proceeded to convert the whole building into flats, but one of the conditions was that I retain the office space as my living space. After all, this particular space was what I'd fallen in love with at the outset, when I'd first bought the old factory building in the mid-1980s. I took up residence in the summer of 2000 and lived, in the same building as my practice, for nearly 20 years, until Christmas 2019 when I finally vacated the flat as part of a general plan for downsizing and succession.

At this time, I decided that the reputation for architecture and design wasn't any longer what primarily interested me, and I decided to concentrate on masterplanning and urban design. I continued to design buildings in the 2000s, but gradually my direct involvement with them reduced. Instead my interest in masterplanning grew and flourished, giving me exciting and varied new opportunities to do what I was passionate about.

The 2000s

Yet again I found myself at the beginning of 2000 facing a great deal of change. I had left the family home in Maida Vale and moved into a new domestic arrangement, living on my own in what had become a fine flat on the top floor of 17 Hatton Street, with the practice offices downstairs next door. But we had lost a series of projects, after investing a great deal of time, energy and travel in them. It was a period for reflection, to take stock and adjust to my new personal and work life.

The return of the staff from Hong Kong had been a challenge. They were much changed: as someone in London observed, 'During the last two years, they have gone feral!' They had gone out to Hong Kong at a relatively young age and had returned matured in the ways of a different culture.

* * *

A few of my former competitors were racing ahead to be global superstars: Foster and Rogers particularly, and Frank Gehry, as well as Tadao Ando whom I had spoken alongside at the event in Tokyo ten years before. I felt like these 'starchitects' had become a bit typecast and had refined their 'brands' such that their buildings were instantly recognisable quotes of themselves and their brand. Clients began to seek them out for the very sensationalism of their branded outputs rather than as architects/artists who solved problems and were free to interpret the world afresh on every project. I decided this wasn't for me: it was all going in the wrong direction and had become more haute couture than high street.

If I am honest, looking back, the wind had been knocked out of my sails a bit, as they say, by my second marital failure and I also started to question whether architecture had been a wise original career choice for me. I became increasingly critical of architecture as a profession: I began to think of it as too locked into middle-class taste, that I had chosen a very difficult path, one where someone with my background had to work extra hard to keep up, and also where the outcomes of the profession were questionable. Fame and self-interest had become more and more revealed as the currency of architects and their clients and building projects; whereas, by contrast, the everyday was being eroded and devalued. But I think it's worth mentioning the positive here: that I have a mind that finds its way relatively easily around complexity and spatial conundrums. Maturity found me focusing on what I enjoyed and was good at, and at this time I was determined to choose and focus more on that, with what my TV-am client, Peter Jay, called my 'can do' attitude.

Firstly, I started to reassess everything by writing and reading much more. I began by writing a simple document for my children which I made into a family album with text by me. I hoped this would give my children and grandchildren some background and context to their family. In terms of my practice I also wrote a book called *Ten Years, Ten Cities* which described my and the office's work over the ten-year period from 1991–2001, and placed designed buildings as part of a continuum of history and context.[21] I then decided to write a book about my formative years, from childhood to the 1980s, when I feel I found myself professionally. The book was called *Place*, and was much more autobiographical than any book I had written up until that time.[22]

The act of writing, reading and reflecting more now I had passed 60 years helped me to examine what I believed in and indeed what was most needed by the world around me. Sitting alone in my new home, I concluded that it was time to reinvent myself once more. I determined to do more creative work on masterplanning and planning in general – while of course continuing with architecture and buildings. The street, the context of the city, and proactive city-making were what increasingly interested me.

On my travels I realised more and more that in a place such as Pompeii I was particularly interested not in the grand monuments but in how people lived at that time. The wonderful courtyard houses gathered around fishponds and gardens. In Egypt, at the Valley of the Kings, I was extremely moved by seeing the homes of the workers who built the great pharaonic tombs. They were excavated, underground dwellings built with decorating skills learned from their day jobs, but grouped together in villages of families – it captured everyday life in an informal and very relatable way. And so I began to further develop the belief I had already and to further accentuate the true value in the everyday and ordinary. I saw more and more that cities were made up primarily of accretions, layered over time in an evolutionary way, and were the work of many hands – everyone contributing to what we call place, home and neighbourhood.

I began with developing further ideas on the work I'd done with the Royal Parks in the 1990s. A TV programme was made, called 'Buckingham Palace Redesigned' (broadcast on Channel 4 in December 2001), which wasn't just about Buckingham Palace and its frontage and walls, but focused more on the relationship with ordinary people and where they stood with the palaces and parks, which we the public now

owned. I felt strongly that Buckingham Palace itself represented a particular British institution: that the monarchy personified a need for continuity that was important to the people of Britain. But it was a structure and setting that society – the public and the monarchy – now needed help with, to re-evaluate it and make more of its possibilities and potential. So I launched into the book, also titled *Buckingham Palace Redesigned*, as a continuation of various ideas I had had during my time at the Royal Parks Review Group.[23] The royal palaces and their parklands are the only green public realm in London. Far from being reminders of something that we are ruled by and fearful of, they present an opportunity for a glorious public realm that we own. My concern is for their full integration into the fabric of London in a positive, creative and meaningful way. The current failure to achieve this synthesis is due to a lack of pedestrian access and a neglect to fully rationalise past changes. The focus on the parks needs to carry on beyond John Nash's early-19th-century work, and we need to integrate the royal palaces and their parklands afresh in our time. John Nash was a consummate urban designer/town planner. He invented so many elements in this genre, such as suburban villas at Park Village East: row houses dressed up as palazzos in Regent's Park, staged pieces of urban design grandeur behind which individual developers could do as they liked. In Lower Regent Street, he developed the shopping arcade as an urban form – the Nash Arcade off Piccadilly – and all this was done at a time when growth in the West End fabric of London was accelerating its democratisation. We need to continue to address the issues of urban fabric growth and democratisation between and beyond them, and the result would be for the parks and palaces and city fabric to be reviewed and planned as one entity. Currently, the parks are walled off from the palaces, the palaces are privatised and the surrounding urban fabric has problems of access and connectivity to the parks. This situation does not acknowledge that the parks are anything other than largesse from royalty – a place where the public are occasionally allowed to walk. I began to dare to look at places, the public realm, as our places – not the monarchy's and not the government's. In the absence of anyone concerning themselves with where our built environment, our towns and cities, were heading, I decided to be bold and assume leadership in 'city-making'.

The British government as expressed by the urban form of London does not make a clear statement of relationships. If we make our places and our places make us, then we have to question who made the places and why and how they are remaking us. Is it right and do we accept it? Architects must be involved in this debate, as well as in the ongoing evolution of the spaces and places within the public domain. This has to be done with humility, collaboration and confidence. I bring to the table the assertion that places do 'make' us. But it is our responsibility to ensure that we agree with what it is that these places are making of us.

From this work I began looking more extensively at 'place as client', which became and still is an enduring interest of mine. 'The place as client' represented for me a version of 'buildings on the couch', but instead this time it was 'the place on the couch'. By

recounting what was going on there in front of me I had the opportunity to apply a sort of psychoanalytic process to the place I had chosen to study, and it aimed at where architects' skills were absent in their application – on the everyday ordinary estate, the street, pavement, public realm – as where we could really make a difference. But there were no fees, no prizes, no magazine coverage for what makes up over 90% of the environment. As Louis Kahn would say, 'What does it want to be?' What is the underlying order that is struggling to get out, and what is the burden of history that holds it back? The answers could nevertheless be achieved by evolution, working with the grain of history rather than against it.

One of my first such explorations was the Marylebone–Euston Road project on which I set out on a pro-bono basis during the summer of 2003. Initially I got a student to count the number of pedestrian crossings, to measure how many barriers and traffic lights there were, how many cafes and restaurants were on the road (which was a surprisingly large number!). I focused on major infrastructure, interchanges, pedestrian flows, commercial addresses, office precincts and landscape improvement. My aim was to create an intellectual framework that would be a catalyst for change; to make it less of an urban motorway and more of a 'series of places'. Our work here actively initiated several key pieces of public realm, and a very significant part of the masterplan was a detailed design study of Euston Road underpass, which is now a much more pedestrian-friendly environment. This all links together with my ideas on the Royal Parks and how important the connections are between the green spaces and the pedestrian experience, as well as some of the related work I had done on the Nash Ramblas, connecting Regent Street from St James's Park to Regent's Park. It also harked back to crossroads and streets and squares I that I'd examined as a student in the USA. I enjoyed this approach and enjoyed looking at what designers needed to do rather than what they did do as defined by the professional confines of architecture. I made proposals for the road, and in case the office or anyone else around me thought this was entirely altruistic I began to connect jobs/commissions directly because of this work. I was able to link Paddington Basin to where I had a current commission at the far end of the Marylebone Road, the Regent's Place masterplan, and eventually designed and built three large buildings there. I was able to improve the road as part of the study so that it was a reverse process to that of Charing Cross; I was looking at what needed to be done in the urban landscape first and then deciding to do a masterplan and then buildings within that. Five or more new crossings emerged as part of the work on Regent's Place – three of them across the Euston Road itself – as did a complete redesign of the pedestrian crossing realm above the tunnel at the junction of Tottenham Court Road and Euston Road.

I met with the Director of the Royal Parks, Mark Camley, and the Crown Estate Paving Commission; I met developers, Transport for London (TfL) representatives, Westminster and Camden boroughs' leaders, and the mayor and his advisers several times – I was starting to operate at a much earlier stage in the process, much further back on the conveyor belt of decision-making. I enjoyed this immensely. Particularly if it also eventually helped pay its way by the commissions that ensued, as it was important to me to prove that this wasn't just altruistic work. I felt it needed demonstrating that it was a worthwhile and fee-earning activity: that architects

should take on the public realm, and that buildings and indeed commissions should grow out of good urban planning. It was, for us, an entirely new and pioneering way of generating work. One of my sayings was that 'planning leads', and so, encouraged, I expanded the study to do further masterplanning work at Euston Station, where I worked for over 20 years on proposals for a variety of clients. I influenced enormously what happened there, as well as in front of and behind the British Library and King's Cross St Pancras where the successful developer, Argent, was emerging on to the forecourt of the stations. I looked at the opposite side of the road, where I subsequently got a hotel commission. Generally speaking I was involved in the brief-writing for much of London's public realm, which to start with was on an entirely voluntary basis.

I was given masterplan commissions from a great variety of clients such as Camden Borough Council, Westminster City Council and several great estates, took on mini-commissions for London's infrastructure, and many local authorities adopted my plans that had begun with the Euston Road. Other local authorities such as Lambeth, Wandsworth, Hammersmith and Fulham, and further afield in Newcastle, Edinburgh and Manchester, engaged me to do work – I was motoring on masterplanning. Many of these ideas were unwittingly incorporated into city plans; once in the public domain my masterplans became public property and ownership wasn't a consideration. To have been possessive about my work would have resulted in it being stillborn and risked it not being realised.

* * *

Taking a step back, I became conscious that over the years I had influenced the shape of many cities, particularly London. The South Bank, Charing Cross, roundabouts galore, the pedestrian realm, one-way streets. I even influenced the choice of location for the Eurotunnel terminus, as I had been asked in the early 1990s, when I was a Commissioner for English Heritage, to look at St Pancras again, since it was proving too difficult to bring new trains into King's Cross. I went there and sketched up a concept (that is now built) of the new flat-roofed station aligning with the springing of the arch at the country end, and persuaded the commissioners to think again about whether St Pancras station should be selected. This changed the whole strategy of the way that part of the city works. Thereafter it was planned that the Eurostar would come into St Pancras and not King's Cross. There were numerous occasions where as architect/planner I influenced the future shape of London and other cities, but didn't actually deliver the resultant architectural or landscape commission. An example was for the Thameslink 2000 railway programme, where I showed how London Bridge station could be substantially reordered, reusing the vaults below. My earlier masterplans for Paternoster Square, London Wall, the South Bank cultural estate and walkway along the River Thames and Smithfield Market in the City were all eventually adopted by others, positively influencing what happened subsequently.

Further encouraged by all of this, I sought a publisher for my ideas. First I wrote a 'Manifesto for London' for a special issue of the *Architectural Review* in September 2007, and then I went on to write *Shaping London*, which the writer and historian Dan Cruickshank called 'The most important and inspirational London book of the decade.

It offers a physical description of the city that is both a perceptive analysis of its past and a vision for the future.'[24] The book took most of the decade to put together.

After the success of my vision for Marylebone–Euston Road, which was informally adopted by the planning departments of both of the boroughs that it passed through, I sought out a bigger canvas to apply this concept of 'place as client'. I began work on the Thames Gateway initially because the then Deputy Prime Minister, John Prescott, had declared it a place to expand London's housing. At that time I was intrigued by lessons that could be learned from a scheme of three courtyard houses that we'd recently built at Petersham, near Richmond in Surrey (Figure 8.1) – a project whose design was led by Aidan Potter and Mike Stowell. I multiplied them up and eventually I was able to show that a tiny fraction of the area could contain all the Thames Gateway housing requirements, about the size of one town in one corner of what was a 15-by-5-mile stretch of land in the Thames Estuary. (Figure 8.2)

The Thames Gateway enabled me to meet ministers including John Prescott, Caroline Flint, Yvette Cooper and the successive mayors of London, Ken Livingstone and Boris Johnson. I was working on this for five years or more and eventually the government asked me to draw up a formal masterplan for the area, which I did. It led to many paths, watercourses and bridges, which were paid for and built. My main proposition and argument was that landscape was the very critical first infrastructure; the initial investment needed to be in landscaping, not jobs and housing. I learned that, to be more effective politically, advocacy needed to be based on soundbites like 'landscape is the first infrastructure' and that models, and particularly diagrams and key drawings, were extremely important in that they made urban design concepts much more accessible to a wider audience. I perfected the image (often a cartoon) that would carry the message simply and powerfully; one politician dubbed these 'vision bites'. Just as the Upper Thames Valley was a pleasant environment, I argued that until the early 20th century, this eastern end of the Thames Estuary had also been valued as an environment for Londoners; it had been a place of weekenders and holidaymakers, with nine piers and places to visit – winter gardens, zoos, aquariums – and where people went hop-picking and strawberry-picking in the summer. It was a place where the environment had once come first, and the aim/vision was to return to it the value it once had.

I then developed a plan for the frontline green industries to tackle global warming, energy generation (the future of the power stations, and what scope was there for tidal harnessing to create new energy), docklands (what was the future of containerisation), sewage treatment (the recycling of waste's future with the growth of London and the public pressure for cleaner water) and ultimately flooding (with substantial sea-level rise, as result of global warming, the Thames needed new plans to defend the capital city from future flooding threat). I envisioned all kinds of ideas which became part of the collectively accepted ambitions for London's Docklands. Richard McCormac said, in a brainstorming session held around that time at Michael Heseltine's house on the Thames Gateway, that it needs the designer to think about these things – and he was right, up to a point. But it needs more than that; it needs someone who understands the processes – the large scale of private investment, plus mobilising political will and then adding public activity through voluntary organisations. The

work of the state-funded and voluntary bodies was very impressive indeed: Historic England, English Heritage, the National Trust, the Royal Society for the Protection of Birds (RSPB) and the Campaign to Protect Rural England (CPRE) were all already hugely influential. I developed and valued an appreciation for the third arm of this way of being effective. I joined with the Civic Trust (now Civic Voice) and the CPRE, and became a staunch advocate of all these organisations.

* * *

My masterplanning and city-making skills were also taken up in other regions and countries. At the outset of the decade I had a major involvement in Manchester, under the direction of the City Council's chief executive, Howard Bernstein, and leader, Richard Leese. My work with them extended from proposals for a 'Sports City' (the new home of Manchester City Football Club) and 'The Arc of Opportunity' (linking the universities and colleges) to the 'Southern Gateway' (around Castlefield Basin and beyond), 'Macintosh Village' (a masterplan in which we also designed and built the Green Building) and most importantly 'Project Unity', which reunified the main university campus around the Oxford Road area. I joined these and other city leaders in envisaging, explaining and illustrating the way forward for towns and cities like Preston, Hull, Chester, Leeds, Newcastle, Birmingham and their like – places that were searching for a new economic raison d'être after years of decline in their major industries. They were exciting times, demonstrating that there was a new and hopeful future for urban centres. The process was partly educational (of leaders and the public, primarily), partly advocacy, but above all it was political and local – each place had its unique problems and opportunities and needed a place-based approach, for which I was invariably asked to help formulate and visualise the possibilities.

In 2004 I was appointed design champion in Edinburgh, to help shape the City Council's view of moulding the city at large. I worked with them and their choice of director for the project, Riccardo Marini. I divided the city up into areas or neighbourhoods, which I called tiles, and gave clarity to each of them with simple visual representations. (Figure 8.3) Advocacy and visual grasp of the primary issues were paramount. These areas primarily followed the route of the new tram and I held discussions, workshops and competitions for urban planning implications for each sector of the city. This was followed several years later by my becoming design champion at Medway in Kent, which was a particularly involved project uniting five towns into one city. My role in Ashford focused on high-speed rail and connections between Folkestone/Ashford and London. I became the design champion for the county of Kent and was consulted on South Essex. All of these activities involved countless meetings with mayors, politicians, city leaders and CEOs of lead developers. I even did a scheme for the small town of Tenterden in Kent, while during the same period my planning work ranged as far as Perth in Australia, where I presented my vision for the future of the city to the mayor and architect/planners. This work on visioning of what could be the potential future of a place had become my special area of expertise. I didn't see it as a lasting role, because others would learn and build on

what I had done – but for around ten years I had reinvented myself and was a leader again in ways of seeing, advocating and doing.

There were many other urban masterplans we did in this decade: for example, for the owners of the former oil rig assembly depot at Ardersier near Inverness, which had aspirations of becoming an eco-settlement; at Nine Elms on London's South Bank, collaborating with other adjoining masterplans in the area around the new American Embassy; and, closer to home, Paddington Basin and adjoining areas where we designed and built The Point, an office building occupied initially by the telecommunications giant Orange. I coined the phrase 'from desk to far horizon' as we designed the interiors and building for TfL at Greenwich Peninsula, as well as a masterplan for the whole peninsula and indeed its connection to the Thames Gateway.

<p style="text-align:center">* * *</p>

Of course we didn't stop designing buildings during this decade. In Hull we built The Deep, an aquarium branded as 'the world's first submarium', which grew out of our overall plans for that city. (Figure 8.4) Chief among our building designs in London in this period were the ongoing Regent's Place scheme and the projects begun in the 1990s with Godfrey Bradman, for the new Home Office building and for Lots Road, Chelsea – all of which had very long gestations as they were part of larger masterplans. Lots Road in particular is still being built as I write this book, and will have taken three decades in design, planning (including a planning enquiry which I personally led) and construction. The Home Office on Marsham Street had begun as a demonstration scheme and ended up as a private finance initiative (PFI) scheme for the French contractor Bouygues. Even now it seems such a complicated and long-winded way to eventually succeed in landing an architectural commission! But people could see that I wasn't solely motivated by adding to our firm's commercial fees – far from it – and that won their confidence. The new Home Office was to stand on the site of three 1960s slab towers that had housed the Department of the Environment. The advocacy revolved around the idea that low- or mid-rise can offer as much density as high-rise, and that a connected-up pedestrian realm, mixed-use programme and integrated works of art were all part of a broader new way of doing 'no-brand' architectural design. I was thus closely involved in the evolution of the project, which became our third government commission after MI6 and the British Consulate in Hong Kong. Because it was embedded in the streetscape of this dense mixed-use part of London, it turned into a fascinating exercise in blending in – almost architecture as a backdrop, like a seamless accretion that would appear to have evolved naturally. First we masterplanned the whole site, allocating housing to the north, and with the uses and pedestrian realm much enriched in comparison to the three original slab towers. The interiors work for the new Home Office was extensive, almost 1 million square feet (the same as the towers achieved), but was within a domestic height of six to eight storeys in three linked and flexible buildings, with additional residential provision not included in this like-for-like office replacement calculation. We managed, with the help of Paul Finch at the Commission for Architecture and the Built Environment (CABE), to appoint the artist Liam Gillick to curate numerous artists in the overall project, and Liam

himself designed the entrance of the facade and the long coloured glass canopy that extends along most of the Marsham Street elevation. A wonderful bonus is that when the canopy catches the sun, the whole street becomes multicoloured – even the trees and buildings opposite – giving rise to the street being renamed by locals as 'Rainbow Street'. (Figure 8.5)

I didn't forget our roots in conversions and adaptations, as in the 2000s we also completed a building for the London Clinic and two National Lottery-funded schemes: one at the Royal Institution in London, the other the former Hancock Museum in Newcastle which became the Great North Museum (Figure 8.6). But these were part of larger cultural masterplans, and delving into their history was a key indicator of where the scheme should be taken – where it 'wanted to be'.

* * *

The Hong Kong office was becoming more independent. After the early projects where I was intensely involved in such designs as Punggol Station in Singapore, Incheon Airport Transportation Centre in Seoul and the West Kowloon Cultural Masterplan, I began to delegate more to Gavin and Stefan, the two partners who had volunteered to run the office in the 1990s. It grew to the same size as the London office during this period, about 100 employees. They designed and built a range of projects like railway stations at Beijing South (high-speed and metro), Guangzhou (high-speed) and for the MTR in Hong Kong – Tsuen Wan West and later Kennedy Town. During this time they continued to do large office buildings like KK100 (Figure 8.7) in Shenzhen and the China National Petroleum Corporation HQ in Beijing. It's a fact of life that reputations don't travel easily. In Hong Kong we have a growing reputation for railway stations and high-rise office towers, and in London increasingly for masterplanning and housing.

* * *

I had started the decade alone in my new flat above the office, doodling and doing overlay drawings of The Deep in Hull, which is now built. I ended it remarried, with my children all settled down and having children of their own, and I had turned 70. In this decade I had reinvented my approach to my work, and begun to write and read more. I looked forward to a new decade where I knew I would be setting out plans for succession and legacy. And I had become the 'no-brand man' in that I had finally escaped categorisation by refusing to conform to any signature look – I had become a recognised artist and a masterplanner as well as an architect.

2010s Onwards

This decade was dominated by succession arrangements, for my practices in London and Hong Kong. These proved more complex and difficult than I ever expected. Time will tell if the right decisions were made. But they were not easy. It hasn't helped that both London and Hong Kong – where our primary offices are based, and where they grew and prospered – are now going through turmoil and change with Brexit affecting one and riots affecting the other. As I write and conclude these memoirs we are also experiencing a global pandemic caused by COVID-19 – the consequences of which are yet to be fully known. It was also the decade to mark the closing of a career, which meant writing my memoirs for the RIBA and deciding on a suitable home and recipient for my considerable archive. I had never forgotten the lesson learned from my grandfather, to collect and then hopefully use this collection to lead future generations.

All the while, as an established office the show must go on, so there were buildings designed and built and masterplans drawn up and presented. In Hong Kong the office was designing and building the Z15 Tower (520m) in Beijing – now completed, but with, as we were getting used to, many twists and turns on authorship and credit. Together with CITIC (client), BIAD (executive architects) and Arup (engineers), we were initially declared the winners for the main parts of a masterplan with several towers. However, after the competition stage the developer side of the client changed, and KPF were appointed to take it forward. They always dutifully credited us as the 'concept architects'; but it didn't stop there, and BIAD, the local Chinese mega-practice, are now claiming primary authorship and ownership of all or most of the credit.

Such is dealing with a different culture a long way from home. However, in the UK too, commissions from competitive situations can have complex unintended outcomes, often with the result that different architects from those originally appointed end up carrying out the work; it was ever thus. I watched as various commissions to other architects were to go a similar way, such as the National Gallery, Paternoster complex and Cardiff Opera House right up to the Houses of Parliament refurbishment and Parliament Square. None of us are sure, either here in the UK or elsewhere, which designs will be built until they actually are, or by whom, or who will get the credit!

* * *

The project for Kennedy Town Station in Hong Kong gives me particularly great pleasure as it is a complex urban renewal project involving conservation, urban planning and several overlapping uses including a spectacular design for a replacement swimming pool on a prominent harbour site. (Figure 9.1) I visited early in 2017 to see the new station and pool, and then returned in 2018 to give a talk at the Consulate and also presented voluntary ideas we had for masterplanning part of the harbour at LegCo (the Hong Kong government offices), as well as to attend the opening of an exhibition of our work in Hong Kong over the past 25 years. The exhibition was opened by Carrie Lam, who was to go on to represent all of Hong Kong as chief executive. I also spoke at an urban design conference and met the clients of M+, the large art gallery we are designing with Herzog & de Meuron (Figure 9.2), and separately met the director of the archive collection as I am depositing various Hong Kong schemes permanently at M+, including the Peak models and drawings. I find it hard to believe it's now almost 30 years since we submitted the original Peak scheme in the competition.

* * *

Back in London I personally was becoming less involved in the practice's building projects and concentrating more on the masterplanning ones. We continued with university masterplans, taking on campuses at Leeds, Kent and Canterbury and further developing our ongoing contributions at Newcastle University. Like hospital masterplanning, university campus masterplanning fascinated me for how the universities invariably began as primarily higher-education establishments in the minds of those that founded them, then grew to acquire complex holistic community characteristics – housing, shopping, workplaces, sports facilities, etc. – again, all the elements that make up the DNA of place. The engagement of the mother town associated with this complex increased in criticalness as each campus grew, often to more than ten times the original size, with its attendant social and economic powers needing to reflect the changed circumstances and relationships. With campuses, as with all towns and cities, there are set standard components that make up their complexity and have to be understood, and there are also geographical and people's

cultural identities overlaid on to this, each one challenging but with the benefits and drawbacks of single-ownership and single-purpose endeavours.

The decade began with Earls Court, which was a masterplanning project straddling Hammersmith and Fulham, and Kensington and Chelsea borough councils, the 'lost' waterway of Counter's Creek being the boundary between the boroughs. These two boroughs were aligned politically at the time of our commission, but one subsequently became Labour-controlled while the other remained Tory-controlled, and after that the whole thing became a battleground between rival ideologies and ways of doing things. I've always felt that the biggest reason for the housing crisis is political uncertainty and infighting. I have seen, during my career, endless schemes and initiatives which appeal to the public and the industries associated with house building but then get messy and delayed through the activities and dominating involvement of politics, whether national or local. (Figure 9.3)

At Earls Court we were selected by a panel who provided an actual physical contextual model into which each competitor was supposed to insert a complete vision, with streets and houses all architecturally resolved as though built out at one point in time. We did our model our own way, which concentrated on processes and concepts – not a detailed and resolved plan, more of an intimation, eventually captured in a slogan that endures today: 'Four villages and a high street'. We also provided an overarching guide to phasing, starting from the edges where established communities existed, and growing towards the centre; this was a project that would evolve and take over 20 years to build. After appointment phase one we masterplanned Lillie Square, which is almost completed and holds around 800 dwellings. Outline planning consent was then granted for the main northern part of the site, and we proceeded with drawing up and getting detailed planning consent for the next phase. Altogether it will deliver around 12,000–14,000 homes with shopping, cultural buildings and offices. A veritable new town yet in the very centre of London.

During this decade we produced numerous masterplans for Grosvenor Estates, Canary Wharf and others included within the Thames Gateway, but I particularly immersed myself in speculating about the line of HS2 (a high-speed rail network from London to Manchester, Leeds and Birmingham) and what it would enable or potentially disable in cities in its wake. I focused my thoughts on Euston, Old Oak Common and Crewe, based on our being very vocal advocates of placemaking and city-making first and railway lines and stations second. I saw many times the various secretaries of state for transport. I kept each of them focused on 'It's not about the lines, or the stations … it's about city-making.' I take the same view about airport expansion, advocating at many public meetings that true city-making within London needs everyone to prioritise and focus on this fact, rather than seeing airport expansion as a specialist transport hub which is merely based on self-limiting arguments of economics and airport business.

Our masterplanning work at this time comprised a lot of thoughtful work at transport interchanges, which – based on our earlier work and experience at Charing Cross, Thameslink, West Kowloon and high-speed lines in China (Figure 9.4) and Singapore – become part of the city. I was entering into a phase where my opinion on bigger political issues was being listened to: I had headlines in the *Evening Standard*

– once on Mayor Johnson's proposal for a Thames Gateway Estuary airport, which I saw as a frivolous sideshow to avoid the real issues of airport expansion, and once on Old Oak Common where I described it (so people keep referring to it) as 'the biggest cock-up in planning London in 50 years'.[25] The collective endeavours of national and local governments and the railway operators in their various forms were planning the Old Oak site to be the best-connected area of land in Europe. This inevitably resulted in a battleground being created, of 'operational' (by which I mean the railways, lines, rolling stock, platforms, etc.) versus 'development' (or city-making, as I called it – with housing, workplace and leisure facilities all potentially included). The latter, as I had laid out ten years earlier and presented to HS2 committees and various successive secretaries of state for transport many times since, was capable of creating at least 25,000 new jobs and 15,000 homes. Instead the 'operational' side prevailed and the site is today covered with train sheds and railway lines that will prevent for decades the bulk of the new town being built adjacent to London's West End. The 'cock-up' is the reality of what we see today. (Incidentally, I checked and the phrase 'cock-up' is thought to be derived from an expression used in pheasant shooting and isn't remotely rude!)

During this time, we had become adept at working with Chinese and overseas investors coming to London, and were often their first port of call, stemming from our reputation among clients in China and the Far East. We thus worked on masterplans in Barking, Enfield and for the Northern Gateway Quarter of Manchester behind Victoria Station, and planned and built out a campus office development at the Royal Albert Docks in London – all for inward-investing Chinese interests.

I was determined to continue with our 'place as client' visioning work and during this decade advocated and helped campaign for the London gyratories (like Vauxhall, Old Street, New Oxford Street and Piccadilly) to be refashioned to become again the public-realm-based, pedestrian-priority-leaning, friendly and legible urban centres that they once were. We held exhibitions, conferences and seminars such as for low-level bridges over the Thames in London's East End and many one-way street schemes reverting back to being two-way.

* * *

As I drew towards the end of my career I began to receive awards like the Royal Town Planning Institute (RTPI) Gold Medal, *Blueprint*'s Critical Thinking Award and the London Mayor's/RTPI award for 'The individual that has done the most for London's development over the last ten years'. I also contributed to retrospectives about my career such as the BBC Four series *The Brits Who Built the Modern World*, which also featured Norman Foster, Richard Rogers, Nick Grimshaw and Michael and Patti Hopkins.[26] Before the drinks reception at the RIBA, Foster and Rogers embraced, and Patti and Michael were as friendly as ever; but at the reception and during filming many people commented on the distant relationship between myself and Nick Grimshaw and how each of us referred to the other by surname only. A sad conclusion to what has been to this day my closest male friendship.

In 2013 I was invited to carry out the UK-wide Farrell Review of Architecture and

the Built Environment. The invitation came from Ed Vaizey, who was the then Tory government's minister for culture, but I had known him for a while as he was a strong fan of my approach to planning and urban design and city-making. In 2010 I had shared a platform with him at his home constituency of Wallingford and advocated with simple diagrams many aspects of holistic thinking in his own town, with new residential expansion placed in the fields outside but within walking distance of the town centre. So when he became culture minister he asked me to do the review. I said I didn't want to be paid and insisted that it should be a genuinely independent piece of critical thinking. So the practice funded it entirely, with a small team led by Max Farrell and Charlie Peel. We delivered it and campaigned for what subsequent reactions it set in train, and in the spring of 2019 I hosted an event, 'The Farrell Review – 5 years on', at the RIBA to show its achievements, which were quite considerable. We concentrated on education through schools, broadening the subjects taught, through highlighting people like me, who grew up on council estates and became architects. The current five-year course and the student fees that are now payable don't equate – I wouldn't have done the course now, it just doesn't make any financial sense. The conclusions of the Farrell Review have dominated my thinking ever since. Its main recommendations are well worth summarising here, and all focus on social mobility:

1. Teach the built environment across all subjects in all schools.
2. Develop online resources for teaching about the built environment in schools at primary and secondary levels.
3. Every town and city should have an urban room, where past, present and future are on display, debated and engaged with by the wider public.
4. Improve access to architectural training and qualification. For diversity we need more varied training routes and lower cost of entry.
5. We should usher in a new era of place review concentrating on the everyday and the existing.
6. What we build now must stand the test of time, including low-energy and loose-fit.

I felt that this all began in the 1960s and 1970s, which was for me a transitional and fundamental discovery period. This influenced me to rethink my priorities: there had to be a less posh, more grass-roots expression in architecture. That's where my interest in conservation, Postmodernism and 'place as client' grew from. I would like to add that for me Postmodernism wasn't primarily a stylistic phenomenon. Yes, it quickly became a style thing, just as Modernism had become, but it offered hope of being more than that. For me it promised (and continues to deliver) a much more democratic and open-ended architecture with history, context, urban planning and other people's taste being much more to the fore and technology being put firmly back in its place.

* * *

As I mentioned at the start of this chapter, I was much concerned at this time with succession, planning to ease myself out of the day-to-day work of leading the two

offices and collectively choosing leaders who would carry the firm onwards. However, my first thoughts from around 2013 were concentrated on where my collection of papers and drawings would go. My plans grew and grew in ambition as I engaged with Newcastle University, and it all came to a head at a dinner in 2015 at the Gilbert Scott restaurant at St Pancras with my wife Mei Xin, the then vice-chancellor Chris Brink, and Teri Wishart, the university's director of development, both of whom I had met only recently. Chris put to me the idea that I could leave my archive to Newcastle but asked if I could/would also help fund a new centre, revitalising in the process a key listed building in the 'cultural quarter' of my masterplan for the university. I agreed that this would combine a public exhibition centre for the School of Architecture, Planning and Landscape with the ideas that I had put forward in the Farrell Review.

I started and continued the Newcastle re-involvement centred on social mobility, as it became the evident ingredient that singled out my life in retrospect. Social mobility in Britain is the worst in the Western world, and all of our party political leaders agree on this – as demonstrated by these quotes from political leaders during the last few years (all cited in David Kynaston and Francis Green's book *Engines of Privilege: Britain's Private School Problem*):[27]

> Britain has the lowest social mobility in the developed world. Here, the salary you earn is more linked to what your father got paid than in any other major country.
> – **David Cameron**[28]

> [W]e will ... tackle the grotesque inequality that holds people back.
> – **Jeremy Corbyn**[29]

> I want Britain to be a place where advantage is based on merit not privilege.
> – **Theresa May**[30]

> We have to fight for a society where the fortunes of birth and background weigh less heavily on prospects and opportunities for the future.
> – **Nick Clegg**[31]

Yet we now have our 20th Eton-educated and 28th Oxford-educated prime minister (at least at the time of writing), in Boris Johnson. This is extremely unfair because we are impoverishing our society by repeatedly selecting from the 7% who attend private schools rather than the other 93%, or ideally from 100% on merit. As Kynaston and Green observe, there is a 'severe democratic impoverishment involved' in our denying social mobility, and it is at its worst in the Northeast.[32] I was convinced that I had made the right choice of where my archive would go when Jill Taylor-Roe, head of the Robinson Library at Newcastle University and in charge of archiving, presented back to me how she and her team would use it in schools and adult learning centres, to show the work I did as a schoolboy, undergraduate and throughout my career, so as to demonstrate and discuss how a child (me) can rise above his background and succeed in spite of obstacles and prejudices that oppose him. But I want my archive to say more

than 'You can do it too'; I want them all to advocate that it's just too difficult and unfair and therefore demand the changes to the underlying cultural systems of our society.

I was reminded again of how, as a child, I had mistakenly thought my running would bring me success in life – I dreamed of winning a gold medal in the Olympic marathon – but I hadn't thought this through. How could I afford to take time off to train and to travel to the Olympics, competing against those with the means, backing, contacts and family support to do so? Then I had gradually learned it was the same for architecture. Peter Murray, director of New London Architecture, an astute observer of the scene, once said to me, 'All famous architects have money to start with or marry a rich wife'. And there is certainly still a snobbish divide between the gentleman amateur architects and those that actually earn their living and act for those that hire them for ordinary development and the like. Are well-known architects (principals that win awards, lead practices and get publicity) primarily from private schools? A quick perusal of Royal Academician architects for example suggests that possibly only one out of the 20 or so attended a state school, and most went on to elite schools of privilege like the Architectural Association or Cambridge University, that even in my student days charged fees, while the others were free. I think it's worth us taking stock of and surveying the current state of our profession in terms of the blatant lack of social mobility, and led by the RIBA, making concrete changes and proposals to facilitate children from less privileged backgrounds to gain entry, and to support them in becoming principal architects. The whole of the cultural output would change for the better if we did.

Indeed, one of the resultant biases of the way the profession works is that its very culture and output is skewed. The glossy magazine features and the fame and awards mostly go to the projects for the already privileged. My undergraduate projects, I now realise, were for the posh people, the privileged and moneyed classes: a house for a musician in Highgate, luxury flats, a private members' club. And yet, as my Farrell Review report emphasises repeatedly, it's the everyday, the ordinary that needs our professional help and should be the focus of our skills. Hospitals are added to and extended until the (no doubt) award-winning first phase is unrecognisable; the high streets, indeed the ordinary street as I was able to demonstrate in the Marylebone–Euston Road study, are neglected by our professions, as are the mass housing estates, particularly ones a few decades old, the older hospitals and so on. Most of our environment does not involve any architects' or any designers' input whatsoever, and it shows. Our everyday environment demonstrates that, like our people, there is what Lee Elliot Major and Stephen Machin describe in their book *Social Mobility and its Enemies* as a 'poverty of ambition, a poverty of discipline, a poverty of soul'.[33]

One of my favourite comparison slides that I show when I give lectures is an aerial view of Dundee and Chelsea hospitals, both of which have within their grounds relatively tiny buildings for Maggie's Centres – part of the programme of such cancer care centres across Britain that Maggie Jencks instigated when she was diagnosed with terminal cancer, and that Charles continued to champion after her death. The vast proportions of the aerial slide are taken up by the hospital, its car parks and its many accretions over time. The Chelsea Hospital aerial also shows adjacent housing and even cemeteries, and both show adjoining streets, car parks and access roads.

The Maggie's Centres – Dundee by Frank Gehry and Chelsea by Richard Rogers – have won national awards and been feted as showing how clever their designers were. They have the indulgence, nay, all the privileges, of architectural society fame, and are very good in themselves. But the rest represents the price that we as a society pay for our indulgences – as there is little, if any, design care in how the huge main hospital is altered and extended, nor in its incremental parking and roads around. It is an underclass, an unbuilt design poverty zone. If our mindset were adjusted, there would be much more creative planning, much more thinking about the brief and priorities, so architecture would not be based on high fashion and would not be primarily a toy, a diversion for the privileged.

The archive and Farrell Centre at Newcastle University, it is intended, will play their part in locally driving change in social mobility. I have written earlier about the archive's potential role in changing things through education. As for the Farrell Centre, it will have a publicly accessible urban room which (as with all urban rooms proposed in the Farrell Review) will show the history of the city, and in which any future proposals for it will be displayed and discussed publicly and openly. Its aim is to facilitate an outreach space for the public and industry professionals to meet and familiarise themselves both physically and digitally with the very place they are in and engage them much more in what its future might be. Our Farrell Review recommendations included having design review panels not just when planning applications of note come in, but also to review the existing environment – whether it be the high street, housing estates or hospitals, whether proposed to be altered or not. This will contribute to changing our perceptions and priorities.

Above the urban room will be a floor dedicated to start-ups and to helping recent graduates get on their feet. I remember my profound shock at going down to London after graduating in 1961, and realising I was just at the beginning once again, like a cruel game of snakes and ladders. My educational achievement had achieved so little for me. Obtaining a good education appears to have a genuinely equalising effect on life prospects in the United States, but in the UK it only has limited power.[34] As Major and Machin report:

> Sociologists confirm that privileged children in Britain who fail to make the mark academically avoid the knock to their life prospects that children from poorer backgrounds experience. This is due in part to the 'social capital' gained from their middle-class upbringing … equipping such children with the social skills ideally suited to the growing number of service and sales jobs in the economy.[35]

Meanwhile, a report on the state of Britain's apprenticeships in 2010 remarks: 'In addition perhaps to social networks, are the – very marketable – "soft skills" and lifestyle and personal characteristics that these individuals acquire, less through their education than through their family, community and peer-group socialization.'[36] The fact that the social mobility debate is now attracting so much comment is encouraging, but the changes that are needed still seem a long way from materialising.

I should add that I don't agree with the over-simple solution of banning all private

schools, because the probable result of that is that everything would be brought down to the lowest level. I didn't agree with killing off grammar schools for the same reason. We shouldn't be seeking to level the playing field by bringing everything down; we should be aiming to bring everything up. Aspiration needs ladders to achieve, otherwise why try? It's just that the rewards are skewed and divide society even more.

* * *

I know from my travels and experience that we in the West are privileged compared to much of the rest of the world. And I know that in retrospect I've experienced privilege myself. Born white and male I've benefited from support as I focused on my career as an artist/organiser. During the 1950s, 1960s, 1970s and 1980s I capitalised on gender stereotyping, for example with my wives and personal private secretaries all dedicated to helping me and indeed privileging me in ways that enabled me to succeed. These were products of their time and circumstances, but no one should have a free ride. Any society must continuously and always be aware of and fight against bleak unfairness and prejudice.

I realise that, unknowingly, over many decades, I organised for myself to benefit, to compensate for the things that were deficient in my background. Leadership, confidence, social contacts and awareness and communication skills were all developed in me, with the aid and help of mentors, teachers, friends, luck and society generally. I proved that someone from my background could do it. But it shouldn't be so hard – truly very difficult – with the need to rely on luck and fortune to make it. The changes I have suggested would alter the cultural output of architecture for the better, and society would be much richer for it.

Endnotes

1 50% in 2012 – see Anon., 'Olympics "dominated by privately educated"', BBC News (3 August 2012), https://www.bbc.com/news/education-19109724; 32% in 2016 – see Sarah Weale, 'Third of Britain's Rio medallists went to private schools', *Guardian* (22 August 2016), https://www.theguardian.com/education/2016/aug/22/third-britain-medallists-rio-olympics-private-schools-sutton-trust (both accessed 27 November 2019).
2 David Kynaston and Francis Green, *Engines of Privilege* (London: Bloomsbury, 2019), p 8.
3 *Ibid.*
4 *The Brits Who Built the Modern World*, BBC Four, first aired on 13, 20 and 27 February 2014.
5 Tristram Hunt, *Building Jerusalem: The Rise and Fall of the Victorian City* (London: Phoenix, 2005), p 31.
6 David Kynaston, *Family Britain, 1951–57* (London, New York and Berlin: Bloomsbury Publishing, 2009), pp 161–2.
7 Andrew Saint, *The Image of the Architect* (New Haven and London: Yale University Press, 1983), p 14.
8 'How to Break into the Elite', BBC2, presented by Amol Rajan, first aired on 29 July 2019.
9 Christopher Hobhouse, *1851 and the Crystal Palace: Being an Account of the Great Exhibition and its Contents of Sir Joseph Paxton and the Erection, the Subsequent History and the Destruction of his Masterpiece* (London: John Murray, 1937); D'Arcy Wentworth Thompson, *On Growth and Form* (Cambridge: Cambridge University Press, 1917, repr. 1961).
10 Alan Clark, *Diaries: In Power 1983–1992* (London: Weidenfeld & Nicolson, 1993), entry for 17 June 1987.
11 *Architectural Design*, vol 43, no 2, 1973.
12 Nick Grimshaw and Terry Farrell, 'Survival by Design', *RIBA Journal*, October 1974, pp 14–29.
13 Terence Farrell and Nick Grimshaw, 'Buildings as a Resource', *RIBA Journal*, May 1976, pp 171–81.
14 Oscar Newman, *Defensible Space: Crime Prevention through Urban Design* (New York: Macmillan, 1972).

15 Deyan Sudjic, 'The Man Who Took High-Tech Out to Play', *Sunday Times Magazine*, 16 January 1983, pp 26–31.
16 *Architects' Journal*, 25 June 1980.
17 *Architectural Review*, September 1980.
18 Frank Russell, ed., *Architectural Monographs: Terry Farrell* (London: Academy Editions, 1984).
19 Colin Amery, 'Pragmatic Art and Spatial Virtuosity', in Frank Russell, ed., *Architectural Monographs: Terry Farrell* (London: Academy Editions, 1984), pp 104–6.
20 'Special Feature: Terry Farrell & Company', *A+U*, December 1989, pp 37–132.
21 Terry Farrell and Jane Tobin, *Ten Years, Ten Cities: The Work of Terry Farrell & Partners 1991–2001* (London: Laurence King, 2002).
22 Terry Farrell, *Place* (London: Laurence King, 2004).
23 Terry Farrell, *Buckingham Palace Redesigned* (London: Andreas Papadakis, 2003).
24 Terry Farrell, 'Manifesto for London: 20 Propositions', *Architectural Review*, September 2007, pp 42–101; Terry Farrell, *Shaping London: The Patterns and Forms that Make the Metropolis* (Chichester: John Wiley & Sons, 2010) – Dan Cruickshank endorsement on back cover.
25 *Evening Standard*, 15 July 2013; *Evening Standard*, 3 May 2016.
26 *The Brits Who Built the Modern World*, BBC Four, 2014.
27 David Kynaston and Francis Green, *Engines of Privilege* (London: Bloomsbury, 2019).
28 James Kirkup, 'Well done, David Cameron: Social mobility and equal opportunities are Conservative ideas again', *Daily Telegraph*, 7 October 2015.
29 Jeremy Corbyn, 'Rebuilding the Politics of Hope', Ralph Miliband public lecture, London School of Economics and Political Science, 17 May 2016, http://www.lse.ac.uk/website-archive/publicEvents/miliband/2015-16-Lecture-Series.aspx.
30 Andrew Lilico, 'Theresa May's "meritocracy" is a recipe for Darwinian dystopia', *The Telegraph*, 12 September 2016.
31 Nicholas Watt and Sam Jones, 'Nick Clegg vows to tackle Britain's lack of social mobility', *Guardian*, 22 May 2012.
32 Kynaston and Green (2019), p 18.
33 Lee Elliot Major and Stephen Machin, *Social Mobility and its Enemies* (London: Pelican, 2018), p 121.
34 See John Jerrim and Lindsey Macmillan, 'Income Inequality, Intergenerational Mobility, and the Great Gatsby Curve: Is education the key?', *Social Forces*, vol. 94, no. 2, December 2015, pp 505–33.
35 Major and Machin (2018), pp 109–10.
36 Hilary Steedman, 'The State of Apprenticeship in 2010' (London: Apprenticeship Ambassadors Network and London School of Economics and Political Science, 2010), http://cep.lse.ac.uk/pubs/download/special/cepsp22.pdf, quoted in Major and Machin (2018).

Image Credits

Figure 1.1	Gorton Monastery and Trust
Figure 1.2	Terry Farrell
Figure 1.3	Terry Farrell
Figure 1.4	Terry Farrell
Figure 1.5	Terry Farrell
Figure 1.6	Terry Farrell
Figure 2.1	Terry Farrell
Figure 2.2	Terry Farrell
Figure 2.3	Terry Farrell
Figure 3.1	Terry Farrell
Figure 3.2	Terry Farrell
Figure 3.3	Terry Farrell
Figure 3.4	Terry Farrell
Figure 3.5	Terry Farrell
Figure 3.6	Terry Farrell
Figure 3.7	Terry Farrell
Figure 4.1	Peter Cook
Figure 4.2	RIBA Collections
Figure 4.3	Terry Farrell
Figure 4.4	Terry Farrell
Figure 4.5	Terry Farrell
Figure 4.6	Terry Farrell / Geoffrey Smith
Figure 4.7	Terry Farrell
Figure 5.1	Stuart Brown
Figure 5.2	Terry Farrell
Figure 5.3	Richard Bryant / Arcaid Images
Figure 5.4	Richard Bryant / Arcaid Images
Figure 5.5	Terry Farrell
Figure 5.6	Jo Reid and John Peck
Figure 5.7	Terry Farrell
Figure 5.8	Jo Reid and John Peck
Figure 6.1	Richard Bryant / Arcaid Images
Figure 6.2	Jo Reid and John Peck

Figure 6.3	Jo Reid and John Peck
Figure 6.4	Richard Bryant / Arcaid Images
Figure 6.5	Richard Bryant / Arcaid Images
Figure 6.6	Terry Farrell
Figure 6.7	Terry Farrell
Figure 6.8	Tim Soar
Figure 6.9	Nigel Young
Figure 6.10	Terry Farrell
Figure 6.11	Anthony Weller
Figure 6.12	Martin Charles
Figure 6.13	Nigel Young
Figure 7.1	Terry Farrell
Figure 7.2	Colin Wade
Figure 7.3	Terry Farrell
Figure 7.4	Colin Wade
Figure 7.5	Keith Hunter
Figure 7.6	Terry Farrell
Figure 7.7	Farrells HK / Kim Yaen Youn
Figure 7.8	Farrells HK / Park Young Chea
Figure 7.9	Terry Farrell
Figure 8.1	Sean Gallagher
Figure 8.2	Terry Farrell
Figure 8.3	Terry Farrell
Figure 8.4	Richard Bryant / Arcaid Images
Figure 8.5	Richard Bryant / Arcaid Images
Figure 8.6	Andy Haslam
Figure 8.7	Farrells / John Campbell
Figure 9.1	Farrells HK / Marcel Lam
Figure 9.2	Farrells
Figure 9.3	Farrells
Figure 9.4	Farrells HK / Fu Xing Studio